contemporary dyecraft

contemporary
dyecraft

over 50 tie-dye projects
for scarves, dresses,
t-shirts and more

MELANIE BRUMMER

FIREFLY BOOKS

Dedication

This book is dedicated to my Dad, who taught me from the start to reach higher; my Mom, who hung in with me through the tough times; and my partner Anton Louw, who walks with me into my bright future.

A FIREFLY BOOK

Published by Firefly Books Ltd. 2010

Copyright © 2010 Metz Press

Text copyright © Melanie Brummer

Photographs © Metz Press

First printing

Publisher Cataloging-in-Publication Data (U.S.)

Brummer, Melanie

 Contemporary dyecraft : over 50 tie-dye projects for scarves, dresses, t-shirts and more / Melanie Brummer.

[144] p. : col. photos. ; cm.

Summary: Includes step-by-step instructions on how to make tie-dye clothing and décor at home, as well as tips, techniques and dye formulas.

ISBN-13: 978-1-55407-729-8 (pbk.)

ISBN-10: 1-55407-729-X (pbk.)

1. Tie-dyeing. I. Title.

746.6 dc22 TT853.5B786 2010

Library and Archives Canada Cataloguing in Publication

Brummer, Melanie

 Contemporary dyecraft : over 50 tie-dye projects for scarves, dresses, t-shirts and more / Melanie Brummer.

ISBN-13: 978-1-55407-729-8 (pbk.)

ISBN-10: 1-55407-729-X (pbk.)

1. Tie-dyeing. 2. Handicraft. I. Title.

TT853.5.B78 2010 746.6'64 C2010-904102-X

Published in the United States by
Firefly Books (U.S.) Inc.
P.O. Box 1338, Ellicott Station
Buffalo, New York 14205

Published in Canada by
Firefly Books Ltd.
66 Leek Crescent
Richmond Hill, Ontario L4B 1H1

Cover and interior design: Lindie Metz

Printed in China

Foreword

It is a great honor to have been asked to write the foreword to *Contemporary Dyecraft* by Melanie Brummer.

I met Melanie when her business was in its infancy. She appeared at Leopard Frock with her big smile, stained hands and arms full of interesting fabric. Her enthusiasm for her craft was totally infectious and I went on to learn many concepts and dyeing techniques from her. Melanie always relished a challenge and through many personal ups and downs she never let us down.

The dyeing of fabric to create interesting surface patterns and colorations is a very ancient craft. Fabric dyes have been harvested over the centuries from remote locations and rare plants and animals. Some of the colors were so rare and expensive that they were used only on garments worn by kings. I am thinking here of the color purple, obtained from trumpet shell snails found only on the island of Tyre, off the coast of Greece. Dyes were used as currency all over the world, purple, at some stages, being worth far more than its weight in gold.

I use dyeing techniques to evoke the timelessness of ancient fabric adornment and to imbue my garments with history and exoticism. I love natural dyes but realize that they are not always practical, and I also know that certain colors can only be achieved with special dyeing techniques. Genuine indigo and deep violets are impossible to find commercially and nothing comes close to the real ox-blood color created by a specialist craftsman. Having said that, I also use specialized dyeing techniques when I want to show that the garment was created and finished by hand. I love the unpredictability and irregularity of the medium as well as the nuance and delicacy of faded colors and dipped edges.

Fashions come and go, so it is important to keep in mind what Coco Chanel once said, "In order to be irreplaceable, one must always be different." To this effect, Melanie has been a great inspiration. She has reinvented herself and her craft many times. She has encouraged new ideas, created new avenues and has passed on her methods with great generosity to others.

May the reader discover the magic and the transformative power of this craft as well as absorb some of the enthusiasm and determination to succeed from the feisty author of this book.

Marianne Fassler

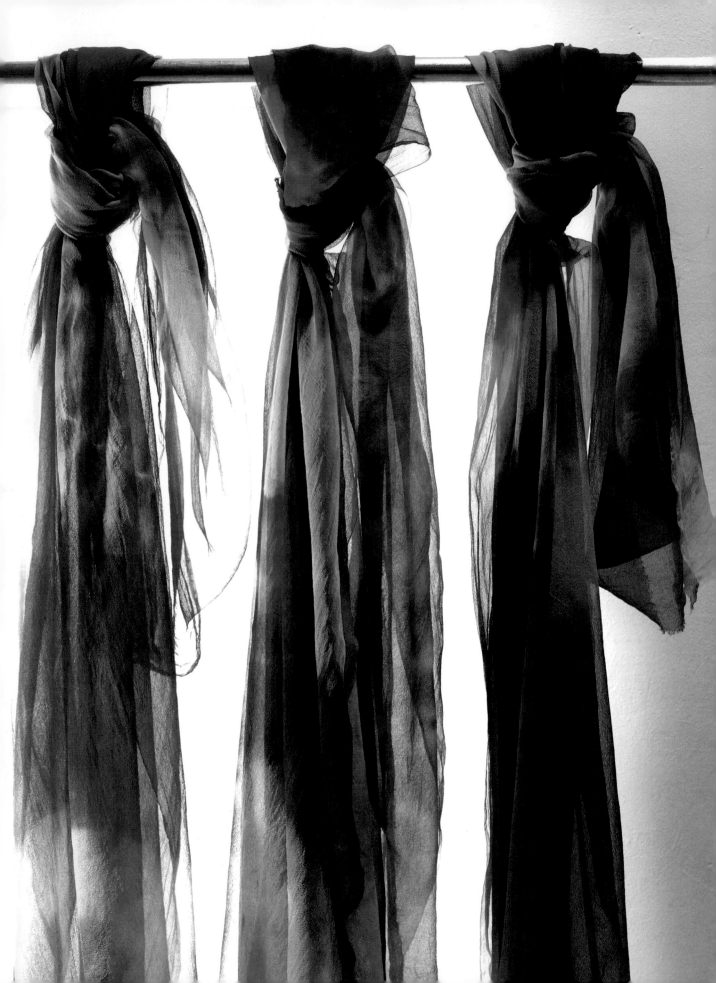

Contents

Introduction

Most people forget that before the industrial revolution, all fabrics were embellished by hand, using basic techniques and materials. Tie-dye is a process where chemistry meets art. Both disciplines are used to produce the end result. Tie-dye has been practiced throughout the world for centuries. In Japan it is a national art form known as shibori, and has been used to decorate kimonos through the ages. In Central Africa it is popular for making kaftans and colorful men's shirts, while in America it found popularity among hippies, who viewed it as a symbol of individuality. In recent years, Prada took it to the catwalk and raised it to couture status. In South Africa it adds a local flavor to several authentic homegrown clothing brands.

Tie-dye is a good way of turning any simple ready-made garment into a dramatic fashion statement. Revive faded clothes with these techniques to give them a second life. Cruise the stores for sale items that can be converted. Create your own individual wardrobe to suit your own individual tastes. Find a white 100% cotton garment in a style you like, choose your favorite colors that go with your existing wardrobe and decide what pattern will best suit your body and mood. Or buy a couple of these garments and transform them visually with different colors – now you have two new outfits in a cut that suits you. Never before have you had such freedom to express your individuality in the way you dress. You are no longer bound to wearing the same clothes your friends are wearing – you are free to be you and let your own special colors shine.

If you're a parent, dyeing is also a marvellous way to keep up with teenagers who tire of their clothes on a weekly basis. Instead of digging deep into your pockets for cash you could spend on other things, raid their cupboards for plain or stained items that they never wear any more and breathe new life into them. Or let them do it themselves. They will enjoy great satisfaction when they wear the clothes and receive compliments on their handiwork. Tie-dye is a great confidence-booster for young people.

It is also an entrepreneurial opportunity for anyone wishing to start a small clothing business from home. It requires minimum start-up and you can be in business almost overnight for a small initial investment.

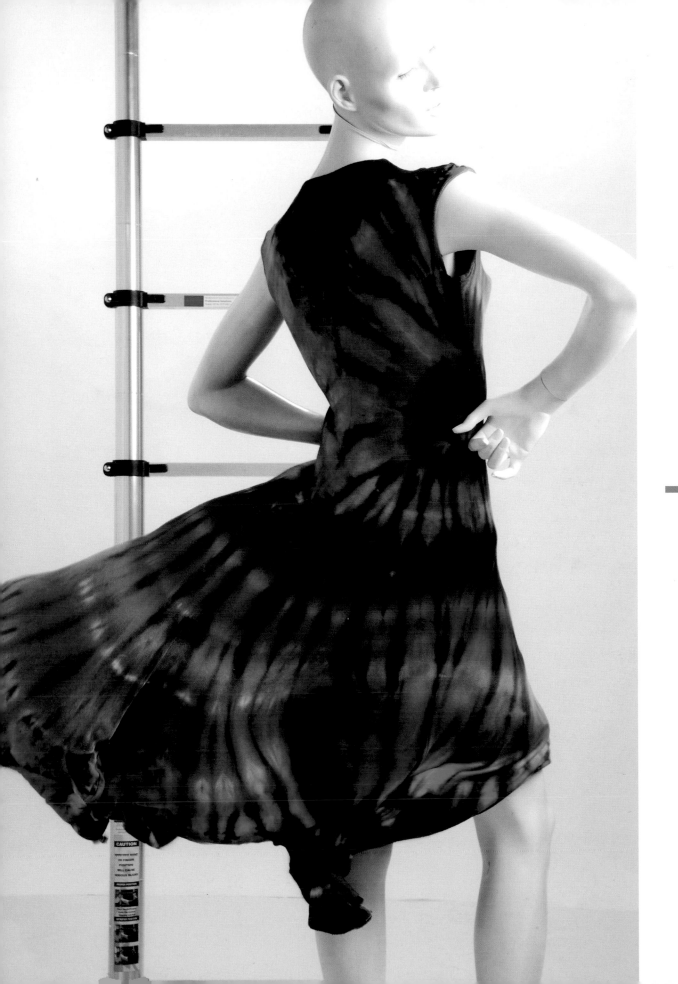

Fabric

Dye is fiber specific. This means that each specific fiber has its own specific chemistry. Dyes that are made for plant fibers will not work on polyester; dyes that are made for spandex will not work on cotton. For this reason it is vital that you correctly identify both the dye and fabric that you plan to work with. In this book we will work with fiber-reactive dyes that are specific to plant fibers such as cotton, linen, hemp and bamboo. The chemical in the dye reacts with the cellulose (plant fiber) in the fabric. **Synthetic fabrics are not suitable for these processes, since the color will only stick to natural fibers.**

Cotton

Use 100% cotton fabric where possible. A poly/cotton blend will usually give a mélange effect – the finish will appear watery, pastel-colored and will not show crisp textures. The dye takes only on the cotton component while it slips off the polyester fibers, which will remain white. It can be compared to the dots per inch (dpi) effect of a desktop printer. The more dots you have in an inch, the more detailed your image will be. With a poly/cotton blend, half your dots remain white. This is what causes the watery, pastel effect when dyeing such a fabric blend.

If you are not sure about the makeup of the fabric you can do a burn test. Light a small swatch of the fabric with a lighter and let it burn out. A poly/cotton blend will make a little plastic ball, while 100% cotton fabric leaves a flaky, white ash. If you are still not sure, stick to light "happy" colors which give better results. Darker shades will all appear drab and gray.

Viscose

This is a man-made fiber that actually takes dye very well. Viscose is made from a petroleum by-product. Petroleum is derived from coal. Coal is created underground when trees are compressed under pressure over time. Trees are made of cellulose fiber; therefore viscose has the right elements to absorb the dye.

Animal fibers

Animal fibers like wool and mohair can be dyed with reactive dyes, although you need to use a different "fixative." Animal fibers favor an acid chemistry, while plant fibers need an alkaloid to fix the color permanently. You can use white vinegar as a substitute for soda ash in the recipes. Colors will vary from fiber to fiber.

Weave and texture

Fabric with a loose, open weave will absorb dye easily and will require tighter bindings for clearer definition. A fabric with a dense weave will not allow the dye to move all the way through the fabric; if it is bound very tightly you can end up with very spindly patterns. A loosely woven fabric tends to end up with heavier cover, while a fabric with a very tight weave will result in very sparse patterns if tightly bound.

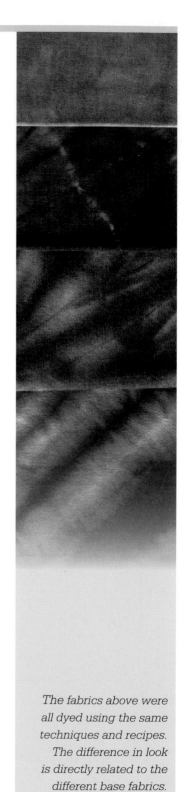

The fabrics above were all dyed using the same techniques and recipes. The difference in look is directly related to the different base fabrics.

You can dye stretch fabrics such as cotton-spandex, provided the blend is cotton rich. The best blend is usually 95% cotton to 5% spandex. Blends with 30% spandex will give a mélange effect similar to a polycotton blend.

A fabric with a brushed surface gives lush, vibrant colors with a velvet look. It is also possible to work on knits or woven fabrics. The choice is yours. What do you prefer? A knit will give soft, flowing textures while the crisp folds of a woven fabric cause bolder shapes.

Prepared for dyeing

Many dyers insist on working on PFD fabric, which is fabric Prepared For Dyeing. The suppliers send it to you from the mill just as it is before they put their color on. PFD fabric is usually a creamy beige color and can have a black speckle. It is not ideal for pastel shades, which perform better on white fabric. The beige color lends a yellowish tinge to any pastel shade you put over it. It is a great fabric to use if you are aiming for an earthy look or dark shade.

White base

White fabric gives clear, true colors. The white flashes that are left behind from the bindings give life to a tie-dye. It also offers the widest range of options in terms of color – you can turn it into absolutely anything you want to! I get very excited about a piece of plain white fabric. It holds a world of possibilities and my imagination runs wild.

Colored base

Colored fabric is more limiting than white. It is a quick and easy way of getting a dramatic two-color effect. Dye is translucent (see-through). If you already have a base color on the cloth, it will shine through the dye you put over top. Even a black will turn into dark red if you layer it over a red shirt. Start with a light colored shirt, bind it tightly and dye it with a darker color. When you open it up, you will have a two-color effect. It is a simple way to make a gift for a loved one, or even yourself.

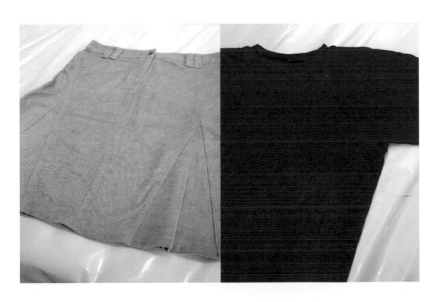

Black base

This is the darkest, heaviest layer of color your can coat a fabric with. Black is made up of all three of the primary colors, in perfect balance, and the fiber is totally saturated with color. If you try to dye a lighter color over black, it has little effect.

There is no such thing as a white dye, but black fabric is suitable for bleached effects. Household bleach can be used to remove dye from the fabric. The dye-stuff can be broken down using chlorine- or peroxide-based products. Please use both products with extreme caution.

Have you ever spilled bleach on your black pants? Bleach strips the dye from the fiber and can damage the fiber itself if over-exposed. If you coat such a garment with dye, those marks will usually still shine through when you are finished. Even if you manage to saturate the fabric enough that the marks do not show, over time, the fabric is most likely to fade there first because of the aggressive nature of the bleach. Those same marks will very likely re-appear over time.

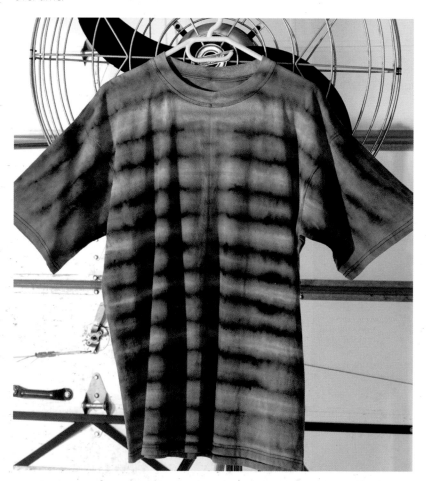

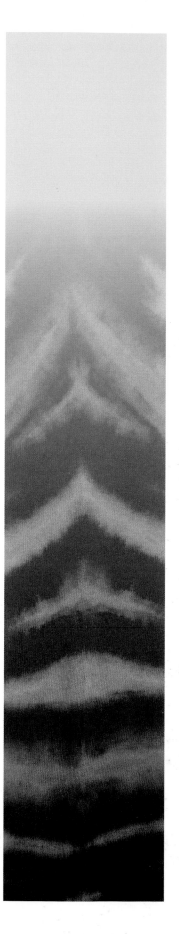

Old and new

New fabric will have the longest lifespan. When it comes from the mill it is usually coated with starch to improve the handle. It might even be coated with an optical brightener or other silicone softener. It is best to wash new fabric thoroughly before you dye it. If you get rid of all foreign chemicals, you have

more control over your process. See page 23, step 2 for details on preparing your fabric for dyeing.

Some of my favorite items to work with are stained garments I find at stores. To begin with, they're cheap; I chase the sales and buy all the soiled fabrics that nobody wants to touch. Dyeing is a wet process done in a container of fluid. Afterward the excess chemicals must be washed out, and this is another vigorous wet process. By the time you have finished, most of the original stain has washed out. The textured finish disguises any traces that might still be left behind.

I also love dyeing old winter sheets when they get that grubby look after years of use. The fiber has been washed so many times that it is wide open to the dye and absorbs it easily. Old white denims can also be given new life when they no longer look crisp. They suck up the color easily and the dye covers any stains you may have picked up along the way.

Sun-damaged fabric, however, is a problem. UV actually destroys the fiber, affecting its ability to hold color. If you dye over sun damage, that mark will usually still be visible as a lighter area when you have finished coating it with dye. I recommend binding the fabric with a pattern that is holistic with the pattern created by the sun damage. A client gave me a batch of T-shirts that had been left folded up in the sun. It burned distinctive stripes across the chest. The only way to repair them with a one-color finish was to add more stripes deliberately, in the same direction.

Coated fabric

A Scotchguard or Teflon coating on a fabric will affect dye absorption. It is not recommended that you work on these fabrics at all. They will only frustrate you. A fiber must be available for the dye to attach. If it is coated in any way the dye cannot penetrate to the site where it binds permanently with the fiber.

Solvent spills and oil drops will take dye in a different way and leave a distinctive mark. This is another good reason to wash the fabric thoroughly before you begin.

Shrinking

Remember that most cotton fabrics shrink up to 10 percent in the length. They are usually more stable in the width. Make allowance for this if you're cutting your own garments. This shrinkage is roll specific and it will vary from one fabric to another, and even from roll to roll. It depends on how tightly the yarn was wound on the loom during weaving. This shrinkage will happen in the first warm wash. If the fabric shrinks a lot, I would recommend that you pre-wash all of it on a very long hot wash before cutting your patterns. Imagine taking the trouble to sew something together. You spend time lovingly dyeing it in the colors you want, you try it on for the first time and it seems to be made for somebody considerably shorter than you are!

If you are buying ready-made garments for dyeing, make sure they are long enough. You do not want to dye it and find that after shrinkage it is too short for you to wear. I once manufactured a range of short dresses. I had very little experience then and we hemmed and finished them before I dyed them. By the time they were dyed I had to sell them as tunic tops because they were just way too short.

Tip: *To avoid the heart-ache of unexpected shrinkage, do shrink tests before you begin. Cut exactly 1 yard (1 m) of the fabric you have chosen to work with. Measure it carefully in all directions and write the measurements down. Put the fabric in a pot of boiling hot water on the stove for 30 mins. Remove it from the heat, let it cool and wash it in your washing machine. Air dry and measure it again. This will simulate process conditions and you will be able to gauge what allowance to make on your pattern.*

Dye or fabric paint?

Many people do not realize that dye and fabric paint are two different products with distinctly different process requirements. Dyestuff is washed into fabric fibers in a hot-water base. There it fixes with the fiber on a molecular level to become part of the fabric. Afterward the excess dye that has not bonded must be washed out. The process is very wet from start to finish.

Fabric paint is a pigment carried in an acrylic base to create a paste for printing or painting onto the surface of the fabric. When it is dry, it must be heat-set to ensure that it does not wash out. It creates a coating on the surface of the fabric. The print process happens on dry fabric with a sticky ink, which is sealed with dry heat.

Reactive dyes explained

Modern reactive dyes were developed between 1890 and 1950. They very quickly took over from natural dyes for a number of reasons. Colors vary greatly with natural dyestuffs, depending on where the raw materials are harvested and what the specific conditions are in that area at the time. Soil makeup, rainfall, seasonal changes and other factors affect the potency of natural dyes. They also fade over time with washing.

Human-made reactive dyes allow you to produce the same color again and again. The powders come out of the packaging at the same intensity every time. These dyestuffs are very robust. They will remain vibrant and bright, wash after wash.

Reactive dyes are susceptible to chlorine- and peroxide-based bleach. They break down at different rates. Some orange shades are very resistant while blues tend to break down very quickly. For this reason, when you bleach a black T-shirt you can expect either a bone-white finish or an orange tone, depending on the chemical used to dye the garment in the first place.

Hot and cold dyes

When you walk into a store to buy a pack of dye, you are usually faced with two choices. One packet of dye says hot, the other says cold. Some people will reach for the cold dye because it sounds more convenient. Others will reach for the hot dye, thinking it is probably more reliable.

When reactive dyes were developed there were two trends. One dye required boiling at 212°F (100°C) for it to be colorfast and was labeled hot. The other did not require boiling to be colorfast and was labeled cold. What the developers did not point out is the fact that a so-called cold dye has an optimum temperature of 149–158°F (65–70°C). This is steaming hot. You can burn blisters on your skin at this temperature. This "cold" dye is actually more robust than a hot dye. The color is stronger and will stay vibrant over more washes than a hot dye.

It is not difficult to see why so many people have had a bad experience with this medium at some time or another. With this book I hope to arm you with enough knowledge to ensure that tie-dye becomes simple and fun.

How reactive dye works – the basics

Dyeing is a physical and a chemical process. Water acts as a carrier to wash dye into fabric fibers. If the dyestuff is not battered into the fibers, the reaction will still happen and the dye will still be used up, but it will not be properly fixed to the fabric. Also, keep in mind that the reaction will only work in suspension, and if the fabric is dry, the bond cannot happen. This medium requires a large container with lots of steaming hot water.

For the reaction to happen properly all the chemicals must be present at optimum levels. They must also be used in the right order. First, you stir the dye (which is sold like a powder) into steaming hot water, until all the lumps are gone. Then you stir in salt, and finally soda ash (see page 22). The salt assists the reaction and makes the colors brighter while the soda ash changes the pH level, allowing the dye to bond with the fabric. The fabric must go in just after the soda ash. If you mix the soda ash in and then leave the mixture to stand for a period of time before adding fabric, you will get a lighter shade.

The whole thing must happen at 149–158°F (65–70°C). It takes some time for the color to develop over the first hour and then the reaction tapers off. I recommend that you leave the whole thing to stand for 24 hours after that to give the bonds a chance to settle. Fabrics that are left in dye for 24 hours will be colorfast and very bright.

Rinsing

Excess dye that may cling between the fibers even though it is not actually permanently fixed must be washed out afterward. This is best done in lukewarm or even cold water. If you wash a tie-dye in hot water you can get the reaction going again with the excess waste that floats around in the rinsing water. I once turned a whole batch of colorful T-shirts a uniform drab gray because I heated the rinsing water. A whole batch of tie-dyes in the tumble-dryer will have the same effect if they are laden with excess dye that has not been rinsed out properly.

This rinsing process is mechanical and I recommend that you keep going until the rinsing water is finally clear. If you get bored and stop halfway, you are bound to be sorry when the excess dye washes out in the laundry and stains all your clothes green.

Once the reaction has finally used up all the active chemicals in the container, you are left with a liquid that has a color, but it has lost its ability to permanently bond with fabric.

Reuse

If you want to control a color you must use fresh dye. Left-over mixed dye can be reused, but it will give you a lighter color that will come as a surprise. I sometimes reuse dye up to four times. It gives you different shades in the same basic color, ranging from dark to pastel. This is a convenient way to dye fabrics in graded tones for quilts.

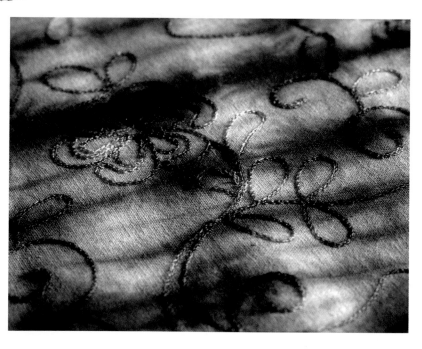

Bleach

Working with bleach is the opposite of working with dye. Patterns are bound the same way, but instead of bashing dye into the fabric, we are destroying the existing color on the cloth. I work with strong bleach for short periods of time. Afterward it is vital that you wash the fabric vigorously until you have removed every last trace of the chemical. If you leave any behind it will damage the fiber and it won't be long before you have holes.

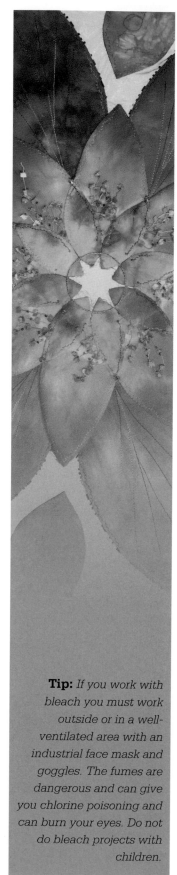

Tip: *If you work with bleach you must work outside or in a well-ventilated area with an industrial face mask and goggles. The fumes are dangerous and can give you chlorine poisoning and can burn your eyes. Do not do bleach projects with children.*

Safety measures

- Respect yourself and take precautions when working with dye and bleach. Work outside or in a well-ventilated area.

- Be aware that you are working with hot water all the time. Wear long pants. I burned my leg once working in shorts.

- Wear a face mask so you breathe in less of the dye powder. If you are doing a small project, a simple paper mask is fine. You can find these at the drug-store. If you plan to work with dye all day, I recommend you suit up with a quality filter mask that filters out fumes and dust. Such masks can be found at hardware stores and industrial clothing suppliers.

- Protect your hands with gloves. Salt burns the skin and long exposure to soda ash burns worse. Everybody seems to have a different preference. Some people like to work in sturdy rubber gloves. I like to work in two pairs of latex gloves. The latex gloves leave you with some sensitivity in the finger-tips. They tend to break down and get holes as you work, so if you wear only one pair the dye sneaks into the glove while you are working. This is why I wear two pairs. When the outer glove gets a hole in, I strip it off and replace it with one that is intact.

- Wear a plastic apron to keep dry. Dyeing is a wet, soggy process and you are bound to get wet yourself. Wear old clothes so you do not mess up new things with splashes and spills. Black clothes also work well.

- I wear rubber boots. The water, salt and soda ash will quickly mess up good shoes. If you plan to do lots of dyeing, get a pair of rubber boots to work in.

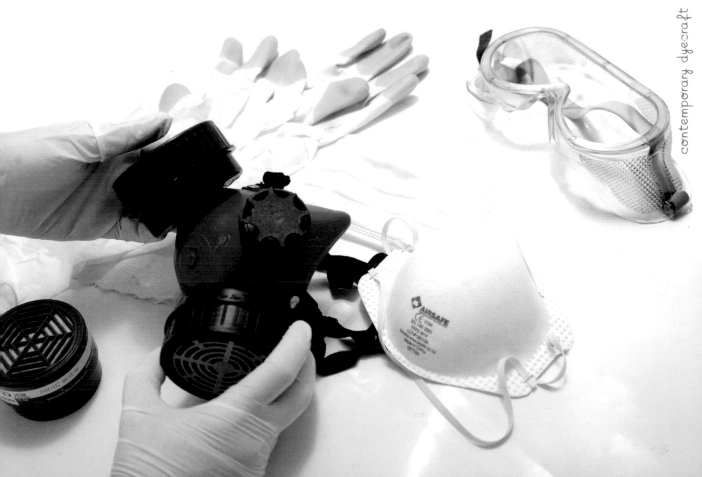

Equipment and chemicals

Containers / Buckets

Why buy new when used will do? I started my business with just a dream and a prayer. I have always tried to harvest tools and equipment from my environment where I could. I collect empty paint buckets, margarine tubs, yogurt containers, water bottles and almost anything else that can hold water. If you use a container for dyeing, you must not eat out of it again afterward.

Spoons

You will need a big strong spoon with a wide head and a long handle to stir the fabric in the hot dye. Holes in the head of the spoon will help to filter out lumps in the dye. I prefer a tool made from stainless steel that has been cast as a single unit. If I use a spoon that has a wooden handle, connected by a screw, it does not last long. The corrosive fluids eat into the joint very quickly and will cause the handle to come off.

A wooden spoon makes a solid stirrer, but the wood absorbs dye. If you use a wooden spoon to stir black dye, and then you try to stir fabric in a pastel pink mixture, you are asking for trouble; the black dye will rub off the spoon and onto the fabric to mess up your delicate pink result.

Tip: *Pastel-colored jobs must be handled with extreme care and I recommend that you wipe down your environment completely beforehand to get rid of any darker powder particles that might be floating around.*

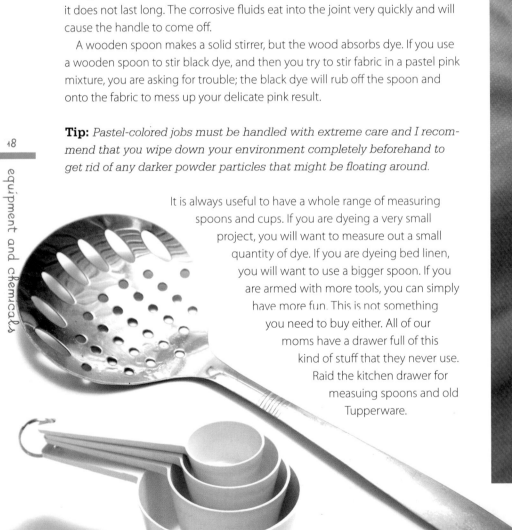

It is always useful to have a whole range of measuring spoons and cups. If you are dyeing a very small project, you will want to measure out a small quantity of dye. If you are dyeing bed linen, you will want to use a bigger spoon. If you are armed with more tools, you can simply have more fun. This is not something you need to buy either. All of our moms have a drawer full of this kind of stuff that they never use. Raid the kitchen drawer for measuing spoons and old Tupperware.

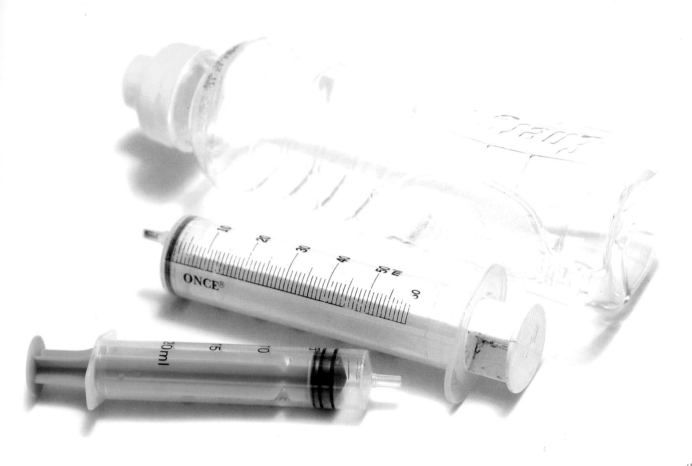

Syringes and squeeze bottles

A selection of syringes and squeeze bottles are handy for multicolor work and applying dye in specific areas. Stock up!

Newspaper

I like to have a pile of newspaper nearby for wrapping projects. If you take a fresh, wet tie-dye and crush it into a pile you can completely destroy the pattern you have so painstakingly worked on. It is possible to overcome that problem by sandwiching the T-shirt flat between sheets of newspaper. This way you can either stack shirts if you are mass producing and you need to create some space, or you can wrap projects that kids have made so they can take them home safely.

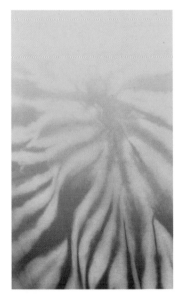

Old towels

I cannot dream of working without my pile of trusty old towels. They are handy for wiping up spills and splashes. I wash them in between projects so that I always have one that is pristine in case I splash dye in my eyes or on my face.

Plastic bags

I collect plastic bags and re-use them again and again. I wrap fabrics in plastic bags when using the microwave to heat multicolor projects to keep the steam in. They protect the patterns when the fabric is lying in a pile until the following day, waiting for rinsing. When I put the shirts in the washing machine after-ward, I throw them in with the bags. By the time I have finished washing the fabric, my bags are clean and ready to use on the next project (and I have not used extra water for the job). I also sometimes put them in a crate and leave them out in the rain to give them a good rinse.

Heat source

When selecting your heat source you need to consider two things: what heat source is readily available, and what kind of project you are working on. For de-tails on how to use different sources, see the section **Applying dye – methods** on page 25.

A pot on an **electric stove** is a very reliable way of dyeing fabric. You can control the temperature and you are not working over an open flame. This is a good technique for large items; for smaller projects simply use a smaller pot.

I use a **gas stove** for most of my commercial work, since it is fast, hot and I can run a series of them. You must be very safety conscious with gas equip-ment. A sturdy gas stove on a metal frame is best for very large projects like bed linen or if you plan to dye many T-shirts at once. I sometimes cheat with my gas stove, setting it on its maximum temperature of 158°F (70°C), then adding hot

water straight from the tap. This technique works better on smaller projects and you have to work very fast. (The temperature of the fabric will cool the dye, which is why this technique does not work well on a very big project.) It also works better in warmer weather than in winter. Often fabrics dyed in this way will fade with time because the dye did not quite make it into the optimum temperature range.

The **microwave** oven is ideal for small projects, especially if you are in a hurry. It is guaranteed heat, fast. The process involves wrapping the garment in a plastic bag and steaming the dye into the fabric.

The **kettle** is my favorite source for making one quick T-shirt in a hurry. (I always leave making birthday presents to the last minute.) Everything must be prepared beforehand, so that you can work quickly once the water is boiled. Most of the projects in this book are outlined using this method; see the **All-in method** on page 25 for details.

There are a variety of **solar cookers** available on the market. I have seen them at flea markets, online and in mail order in magazines. As long as they heat the dye to the optimum temperature, any of them will work. However, some solar cookers work very slowly.

Miscellaneous tools

A **thermometer** is handy to have, although not necessary unless you plan to mass produce. I use a glass thermometer that reads up to 212°F (100°C).

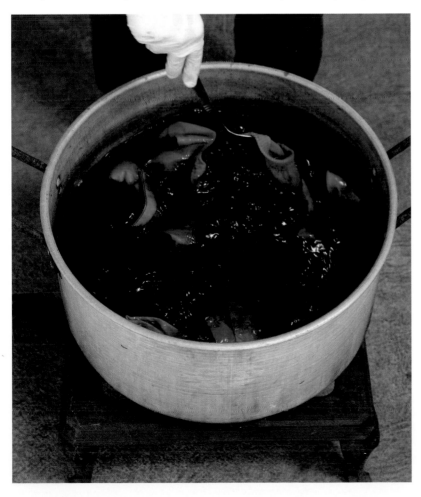

Tip: Do not leave the dye to stand and cool before you put the fabric in. It must go in when the dye is still steaming hot.

I like to work with a **hose** that has a solid nozzle. It is kinder on your back than carrying buckets of water, and it is handy for blasting away spills and accidents.

Crocodile clips are very useful for some projects, but not vital. I bought a whole bucketful for a commercial job that just could not be done any other way, and since then I cannot live without them. I use them to hang garments from the edge of buckets when I only want a small portion of the fabric to be suspended in the dye. You will find yourself using them for all sorts of other things around the house once you have them.

If you want to repeat a project with the same effect, you must work with a **notebook and pencil** nearby to record your methods as you work.

I use a variety of **elastic bands** and string for binding the patterns. The thickness makes little difference. It is merely a mechanism for creating pressure between the layers of fabric. Collect all sizes: you will need small elastic bands for small items, and large ones for big projects like bed linen. Tying an elastic band in an *open* position means the loops are spaced apart, while *closed* means they are all bunched tightly on top of one another in a solid band.

Chemicals

Dyeing is a chemical process that requires three main ingredients (in addition to water, which acts as a carrier).

Dye
There are a variety of reactive dyes on the market and most work in much the same way. Instructions can usually be found on the packaging; make sure you read the directions carefully before you start. Reactive dye is usually sold in art, craft or fabric stores.
I prepackage my own house brand of dye – **Slipstream Dye** – which is available for purchase on my website, **www.dyeandprints.co.za**
All the recipes in this book are demonstrated with Slipstream dye and all the measurements given are tailored to my brand (but you can, of course, use any brand you like!).

Salt
Salt helps activate the chemical reaction and will also ensure your project turns out nice and bright. A general ratio of salt to dye powder is 4:1.

Soda ash
Soda ash (also known as **sodium carbonate** or **washing soda**) is a chemical that changes the pH level of water. It acts as a water softener, and helps the dye "fix" to the fabric; it is therefore sometimes sold in art and craft stores as "fixative." Soda ash can also be found at swimming pool supply stores or in the pool section at your local department store. Generally you should use the same amount of soda ash as you do dye powder, in a 1:1 ratio.

Resist dyeing step by step

Tie-dye is a form of resist dyeing, similar to batik. Excluding dye from certain parts of the fabric creates the pattern. This is achieved by folding, manipulating and then binding the fabric tightly. The pressure created between the layers of fabric stops dye from penetrating into them. In this way dye only covers certain parts of the fabric, while other areas are protected. Because you work with the entire garment you end up with a continuous pattern across the seams.

Flat color is not a tie-dye technique. The fabric is not tied up at any stage and the final finish has no texture, so it cannot be a resist process. I will still explain flat color in this book (see page 30) because so many people ask how it is done. A perfectly smooth flat color is actually more difficult to achieve than a textured finish.

1. Choosing colors

I believe that you can use just about any combination and get a great result. I have experimented with color combinations that seemed very far-fetched and they worked very well. I've made color suggestions for each project in this book, but do not be afraid to experiment. Work with colors that you like and that go with your existing wardrobe.

2. Preparing the fabric

When a new fabric leaves the mill, it can be coated with any number of substances. Most factories wash on starch to make the fabric feel thicker and firmer. They may add an optical brightener to make the white look crisper. Silicone softeners are used to improve the handle. If the fabric has made a long journey into the country by sea, it can be just plain dirty. It is important to wash fabrics and garments before you dye them to remove any foreign chemicals or spills that may affect how the dye takes on the fabric. Oil and solvent spills will absorb dye in a distinctive way and create a mark that is visible on the dyed item.

I wash all fabrics before I dye them in my washing machine. When they come out of the spinner I wrap them in plastic to keep the moisture in. Do not dry the fabric before working with it. Damp fabric is the easiest to work with. The moisture weighs it down a little so it does not spring open when you fold it. Moist fabric is easier to fold and manipulate than dry fabric, which is springy, and very wet fabric, which tends to suck onto the surface on which you are working.

Dry garments are also more susceptible to air bubbles; if you put a dry garment into a dye bath and an air bubble remains trapped between the folds, it will prevent the dye from taking at all in that spot. When you open the fabric to wash it you will find a distinctive white mark where the bubble was. This mark looks almost as if moths have eaten the color out of that spot. It is very difficult to cover it with dye so that it does not remain an eyesore. Often the only way to fix such a mark is to paint something over it with fabric paint or appliqué some embellishments over the problem area.

3. Mixing dye

How you mix the dye will usually depend on which technique you choose to use. The basic principles are the same though. You need hot water to act as

a carrier for the dye. The less water you use, the stronger the mixture and the brighter the shade. Pastels are produced by adding more water to the recipe. Check the instructions on the dye packet to see how much water you need.

The dye powder goes into the hot water first. (Mix dye in a pot if you are dyeing on a stovetop; use a bucket if you are just doing a small project and using a different method.) Make sure you stir out all the lumps. If a lump in the mixture becomes trapped between the layers of fabric, it creates an unsightly mark.

Tip: *If you want to make sure you have no lumps in your dye bath, you can mix the dye with a small amount of water in a separate container. Strain the mixture through a fine fabric like habotai silk to get rid of lumps before you add the mixture to the rest of the dye bath. I usually just stir like mad to get rid of them, rather than add a whole extra step. The decision is yours and will depend on your project.*

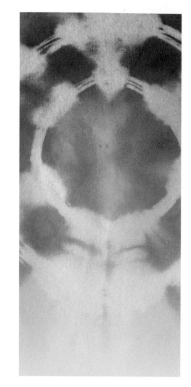

Once all the dye is properly dissolved add salt. (A good ratio to use is 4 parts salt to 1 part dye; so if you use a 10 gram packet of dye you should use 40 grams of salt.) Stir well until it is all dissolved. It is important that the dye goes in before the salt, as the salt affects the solubility of the dye. If you add dye to salty water you will have a hard time removing the lumps.

The soda ash is the third and final chemical to go in. It activates the dye

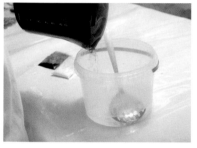

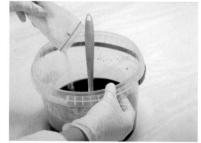

and allows it to bond permanently with the fabric. You should use the same amount of soda ash as dye; so if you use 10 grams of dye powder you should add 10 grams of soda ash. This also needs lots of stirring to dissolve.

It is very important that the fabric goes into the dye as soon as the soda ash has been added. If it is allowed to stand the chemicals will begin to react, and after a period of time some of the chemicals will become used up. If you let mixed dye stand before adding the fabric, you may end up with a softer shade than you had hoped for.

4. Applying dye – Methods

There are different ways of getting the color onto the cloth while hot. How you apply the dye will depend on the size of the project, how many colors you want, and how they are placed.

Stovetop

The most reliable way to get color onto cloth is directly in a pot on the stove. The fail-safe technique is to fill the pot with water, dissolve the dye and add the salt. Add the fabric and stir vigorously for 20 mins to half an hour. Add the soda ash and stir over the heat for another hour. This process thoroughly bashes the color into the fibers while allowing enough time for the chemical reaction to take place all over the surface of the fabric.

But who wants to go to all that trouble when there are easier ways? I have discovered that the keys to good color are really heat and time. If you can heat the process for a certain amount of time, your colors will be bright and fast.

All-in method

My favorite cheat technique is to heat the water to a higher temperature than necessary – above the optimum temperature range of 149–158°F (65–70°C). You can heat the water in a kettle or over the stove in a pot. I boil the water and then add all the chemicals quickly (dissolve the dye first, then the salt and soda ash). Finally I add the fabric and jiggle it for about for 5 mins. I put the container aside until the following day when I come back to rinse. Because I start with very hot water, it has time to cool through the optimum temperature range as it stands and it gets the job done just the same. I call it the All-In Method because I just throw everything I need in a bucket and go.

Microwave

The microwave is ideal for small projects, especially if you are in a hurry. It is guaranteed heat, fast. First you heat and mix dye, using one of the above methods. Then you can either soak the fabric in the dye, or apply it to certain areas using a syringe or squeeze bottle. Before microwaving you must wrap the wet fabric in a plastic bag. Put a twist in the bag to squeeze out as much of the air as you can. Put it in another bag and do the same. Put it in a third bag and twist it shut. This may seem excessive at first, but it creates a very effective packaging to steam the fabric in. If you tie a knot in the bag it will burst in the microwave (and give you a huge scare). If the fabric dries out it will burn and can even catch fire.

The common question is always "How long do you leave it in the microwave?" That will vary depending on the size of your project and the power of your microwave. I always try to err on the side of caution: I put it in for a few minutes on a low setting, take it out and test it. If the bundle is hot all around, I stop. If it has cool spots, I put it back in for longer. By heating the bundle very hot you ensure the color fixes to the fabric.

5. Rinsing

Rinsing is a mechanical process aimed at removing all excess dye that has not actually bonded with the fibers, and that might still be trapped between them. For best results it is done 24 hours after the dye has gone on. A 24-hour

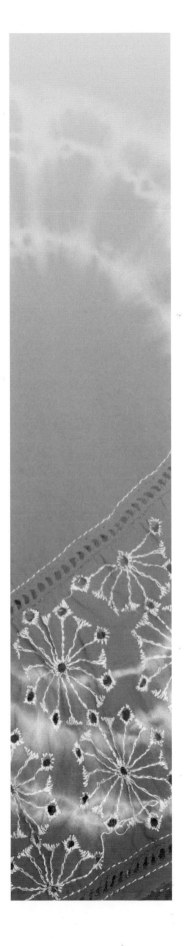

window gives the chemical bonds a chance to settle and strengthen. Fabrics left for 24 hours have the best chance of being colorfast.

Use a series of containers with clean water to do the job. Vigorous jiggling and rinsing is required, but do not rub the fabric. You will find that the rinsing will go on for longer than you might at first expect. If you get bored and stop before the excess has been thoroughly removed, it will not change the look of your project; instead it will most likely change the color of your laundry when you put your project into the machine for its first wash. It is in your own best

Tip: *Remember that wet fabric looks considerably darker than dry fabric. Water has reflective qualities that make the colors look more vibrant in the light. When the watery film has evaporated, the colors will appear softer and lighter. If you want to know what your project really looks like, you must reserve judgment until right at the end of the process when the fabric is completely dry.*

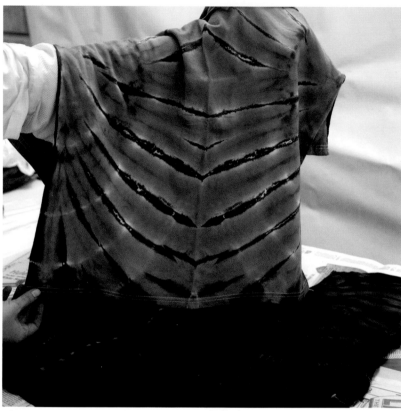

resist dyeing step by step

interest to do a good job the first time around. Once the initial excess is washed clear, the color will not continue to wash out over subsequent washes.

Use some fabric softener in your last rinse so that your garment not only looks nice the first time you wear it, but it feels and smells nice too. Fabric softener is a nice touch if you are making a gift for a friend or loved one. Fabric softener says "I care." If you are making tie-dyed clothing for resale, fabric softener will boost your sales too. I used to watch customers in my stall at the flea market. They would respond to the smell of a familiar fabric softener without even realizing it. We have all experienced the comfort we feel when we smell our mother's household brand.

6. Drying

A fresh tie-dye is best dried indoors. I put T-shirts over a hanger in a well-ventilated area. If you hang a fresh tie-dye over the a clothing line to dry, the sun heats the fabric along the line where it is folded. This heating can burn a stripe into your new work. Excessive UV light will also fade the color.

If one side of the project is a dark color and the other light, the two sides should not touch when you are drying the fabric, or the color might transfer to a place that is conspicuous and ugly. I ruined a perfectly good tie-dye once when I hung it to dry with the light areas touching the dark ones.

7. Cleanup

Dye is water soluble. All you really need to clean up is water. The powders float in the air and settle on everything – you might not even see they are there until you add some moisture and the colored spots emerge. When I have finished working I spray down the entire area where I have worked with a hose.

When I have finished working with dye, I throw my dirty clothes straight into the washing machine. (I once damaged my good white shirts because my workshop clothes were in the laundry basket with them for a week.) I then get straight into the shower for a quick rinse. This is not necessary if you are doing just one small project, but I really recommend it if you have been playing with dye all day. It is never a good thing to expose our bodies to unnecessary chemicals.

If your hands become stained you can break down the color with bleach. I do not like to bleach my skin and prefer mechanical means. A scrubbing brush can go a long way, and then I simply wait a day or two for the rest to wear off. You will find your hands pick up as much of a stain in the rinse water as when you do the dyeing. Wear your gloves for the rinsing process too if you want to avoid getting blue hands.

8. Subsequent washes

If you laundered the fabric thoroughly on the first wash, you should not have trouble with subsequent washes. If you feel you may not have rinsed out all excess dye properly, make sure you wash it the next time with your dark clothes in case more dye runs out and stains your wash.

Do not wash your tie-dyed clothing in peroxide or chlorine bleach. It will fade the color. A detergent with bleach will do the same.

Projects

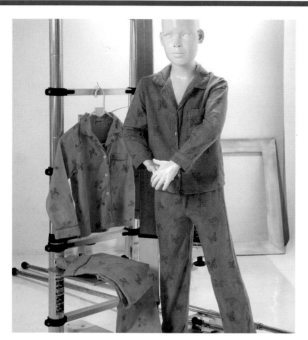

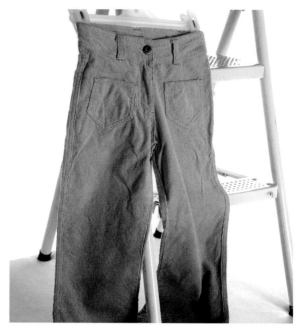

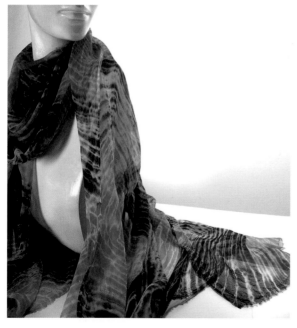

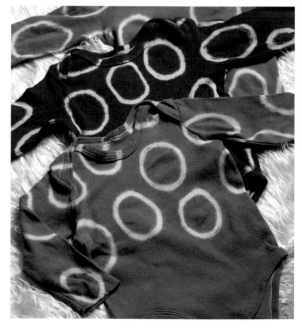

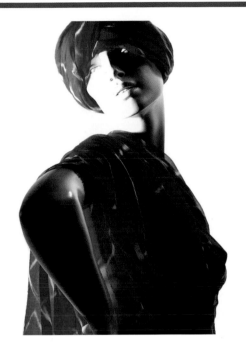

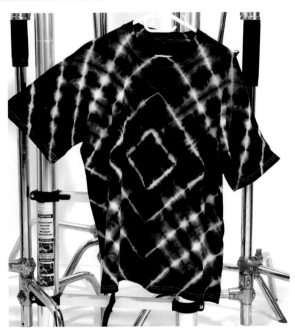

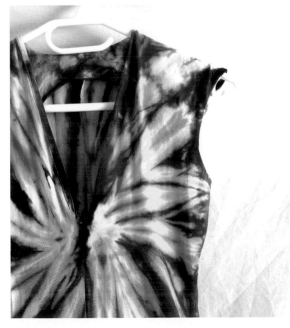

Flat color in a pot

I enjoy overdyeing printed fabric. The printed butterflies are not affected by the process. Note how the polyester piping does not take up the dye either.

Dye quantity

For intense shades use the dye in its most concentrated recipe. For paler shades add more water. If you wish to achieve a soft, pale hue like a baby pink, you can add up to twenty times more water to the mixture.

Always bear in mind that dyed fabric always appears darker when it is wet than when it is dry. Dye to a darker shade, so that when it dries "back" you are close to the shade that you need.

To test the color, include a loose swatch in the dye pot and take it out when you think it is ready. Rinse it well and iron it dry. Compare the swatch to the color you want. If it is still too pale, continue to stir the fabric in the dye for a longer period of time. This can save you a lot of time and trouble in the long run and ensure that you don't have to start all over again if you decide right at the end that it is too light.

Preparation

Wash the fabric thoroughly and spin it in your washing machine. If you do not have a washing machine to spin the excess moisture out, wring it out and leave it to drain overnight. The fabric absorbs dye best in a damp state (see page 23 for more details on preparing fabric).

Wear old clothes and set up all the equipment you will need for the project. Put on your apron, mask and gloves. Dye splashes are unavoidable, so be prepared.

Dyeing and washing the fabric

1. Select a pot that is large enough for the fabric to float around in comfortably. The fabric must not be squashed. Pressure between creases will create a blotchy effect. Flat color wants space!

2. Fill the pot with hot water and place on a heat source (i.e., stovetop). The amount of water will depend on how much liquid is needed to cover the fabric comfortably, without it being squashed in and without overflowing when stirring. Experiment by putting the fabric in the water first to check for fit.

easy

YOU WILL NEED

Light-colored pajamas with printed motif

Stove

Large pot

Stirring implement

Dye

Salt

Soda ash

Fabric

Towels for spills

Thermometer (optional)

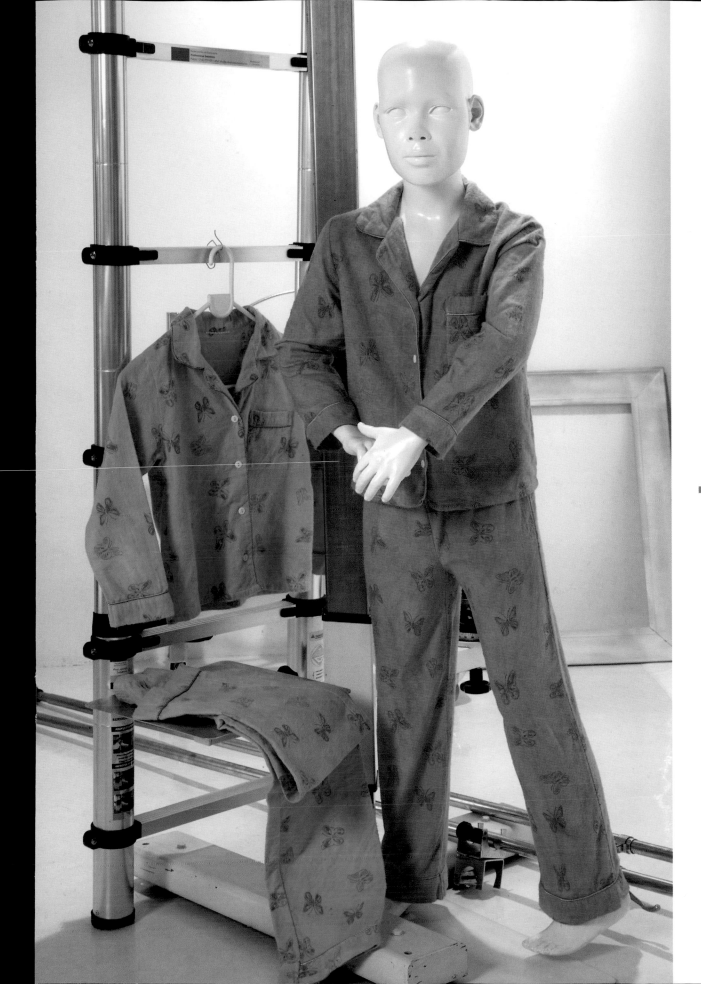

Remove the fabric again and put it one side to drain.

3. Heat the water to lukewarm and stir in the dye powder. Stir very well until all the lumps are dissolved. Continue to raise the temperature.

4. Stir in the salt. Make sure it is all dissolved.

5. Stir in the fabric. Keep stirring for 10 mins to half an hour, until the liquid temperature is at least 149°F (65°C).

6. Stir in the soda ash.

7. Continue to stir the pot for 30 mins to an hour. The longer and more vigorously you stir the fabric, the more even your color will be. If your end result looks blotchy, it is either because the pot was too full or because you did not stir the fabric enough.

8. Remember, you are trying to get an even color all over. Every square millimeter of fabric must have the same amount of dye pushed into it.

9. Try to keep the temperature between 149 and 158°F (65 and 70°C). It is not good to boil the dye as this will affect the color.

10. Remove the fabric from the pot, plunge it immediately into a bucket of cold water and rinse vigorously. Move the fabric into warm, soapy water and wash vigorously. Do not rub! See pages 25–27 for further details on rinsing.

11. From there the fabric can be laundered in your washing machine on a long, warm cycle with lots of soap. Do not leave it to lie in a pile for any length of time as this can also cause blotchiness. The excess dye that has not fixed with the fabric must be flushed away to avoid it being activated again at a later stage.

12. Dry flat indoors.

Tip: *If you're using a gas stove and the fabric lies still over the flame, a "hot spot" may develop in the color. Be sure to stir the fabric frequently to avoid this.*

flat color

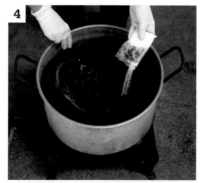

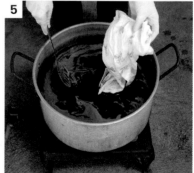

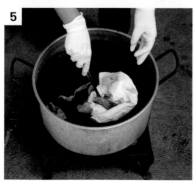

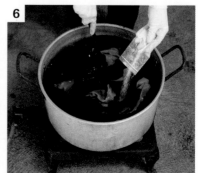

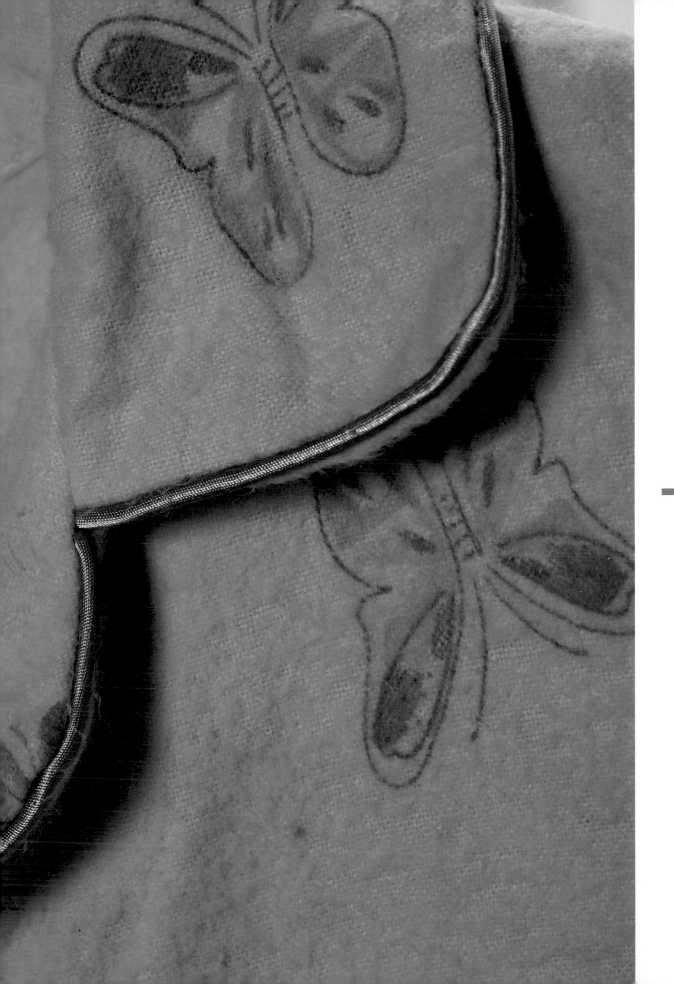

Flat color in a washing machine

Some machines are better suited than others for home dyeing – the more primitive the machine, the better. A machine whose cycle can be set manually is best. A twin-tub washing machine is the easiest of all.

The dye needs to be heated up in suspension to work. It must be mixed with water and it must be hot when it goes onto the fabric.

To achieve a smooth, flat color you have to keep the fabric moving at all times so that you batter the dye into every fiber evenly. As soon as the fabric is squeezed in a crush, the pressure will create uneven marks.

Dye quantity

Quantities will depend on the size of your machine and the shade of the color you want. A washing machine often struggles with only one small item in it. I recommend that you dye at least two pounds (one kilogram) of fabric in the machine at a time. You can add more, but do not overload the machine. As soon as the fabric becomes tightly crushed into the space, it will cause a crackled mark.

One dye pack (which usually contains 10 g of powder) is sufficient to dye approximately half a pound (250 g) of fabric a fairly intense shade. Use the proportionate number of packs to the weight of the fabric you are dyeing.

Preparation

It is very important that you plan your route before you start out. Lay out everything you might need before you begin. This is not the kind of job you want to walk away from halfway through.

Weigh the dry fabric to work out how many packets of dye you will need. The amount of water in the machine will affect the intensity of the color. The first few times you do this, keep extra dye packets on hand that can be added to the dye bath if you see the shade is too pale. Place these somewhere nearby so you do not have to walk away from the machine once the process has started.

Wash the fabric beforehand. As it comes out of your washing machine, wrap it up in plastic bags to keep the moisture in (see page 23).

Dyeing and washing the fabric

1. Heat a pot full of water on your stove. (The quantity of water does not matter; it is simply a carrier for the chemicals, which you have already measured according to the fabric you want to dye.) Stir in all the packs of dye that you need for the job. Make sure you get rid of all the lumps. Lumps will cause ugly marks on the fabric. Once you are sure there are no more lumps in the mixture, stir in the salt. **Do not touch the soda ash for now**.

2. Fill your washing machine with hot water. Reactive dye has an optimum temperature of 149–158° (65–70°C), which is steaming hot. Cooler temperatures will still get a result, but do not expect the color to be exact or to last well without fading.

YOU WILL NEED

Garment or fabric

Twintub washing machine

Large pot

Dye

Salt

Soda ash

Stirring implement

Stove

Laundry detergent

3. Add the fabric and start the machine. Add the dye to the machine. If you are worried about lumps, strain the dye through a muslin cloth into the machine. Let the machine run for 10–15 mins to batter the dye thoroughly into the fibers.

4. Mix the soda ash in a little hot water in a separate container. Stir out all the lumps. (Again, the quantity of water is not important.)

5. Add the soda ash mixture to the machine and run it for as long as possible. An hour is ideal. Shorter time frames will give paler results. You will probably have to reset your machine a couple of times to do this.

6. After an hour drain the dye bath and refill the machine with clean water immediately. Add laundry detergent and put your machine on the longest, hottest cycle to wash out excess dye. All the excess may not wash out in this first wash, so be careful with newly dyed items. If you used a dark colour you may want to reset your machine and wash the fabric a second time just in case.

7. Dry garments indoors on a coat hanger or lying flat.

Tip: *Dye color appears much darker when it is wet. You will only know what the final shade is at the end, when the fabric is dry.*

Graded color or dip dyeing

Fabrics that have been dyed in this way have not been tied up or bound to create a pattern. This technique is closer to putting on a flat colour. It requires concentration. This is not a technique you should try if you are distracted in any way.

Before you start, find a way to hang the fabric in the dye bath from above. I attached the pants to the hanger with crocodile clips, tied a rope to the hanger and suspended it from a broomstick. To raise the fabric I adjusted the length of the rope.

1. Start by hanging the fabric in clean hot water. Mix the dye in one bucket (adding salt once the powder dissolves), and the soda ash in another.
2. Add a small dose of dye and soda ash (in corresponding quantities) to the pot and stir well for 5 mins. Raise the fabric by one centimeter. Add another small dose of dye and soda ash and stir for 5 mins. Raise the fabric.
3. Keep doing this until the fabric is lifted clear of the liquid and you have used up all of the mixed dye in the buckets.
4. Rinse the fabric until the wash water runs clear (see pages 25–27). Dry indoors on a hanger.

Tip: *This technique is rather advanced for beginners and is best learned first-hand in a class. However, I have included these basic instructions because so many people ask about it.*

advanced

YOU WILL NEED

100% cotton pink pants

Coathanger

Rope

Broom handle

Crocodile clips

Pot

Stove

Purple dye

Salt

Soda ash

Stirring spoons

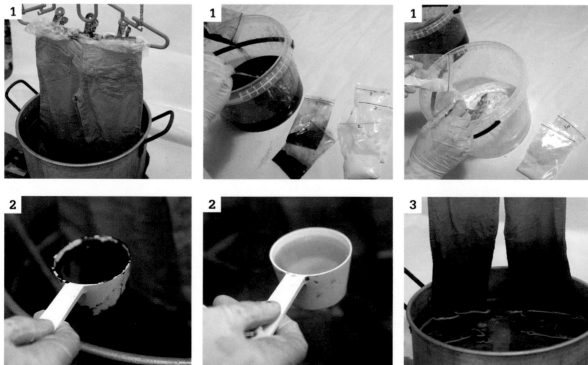

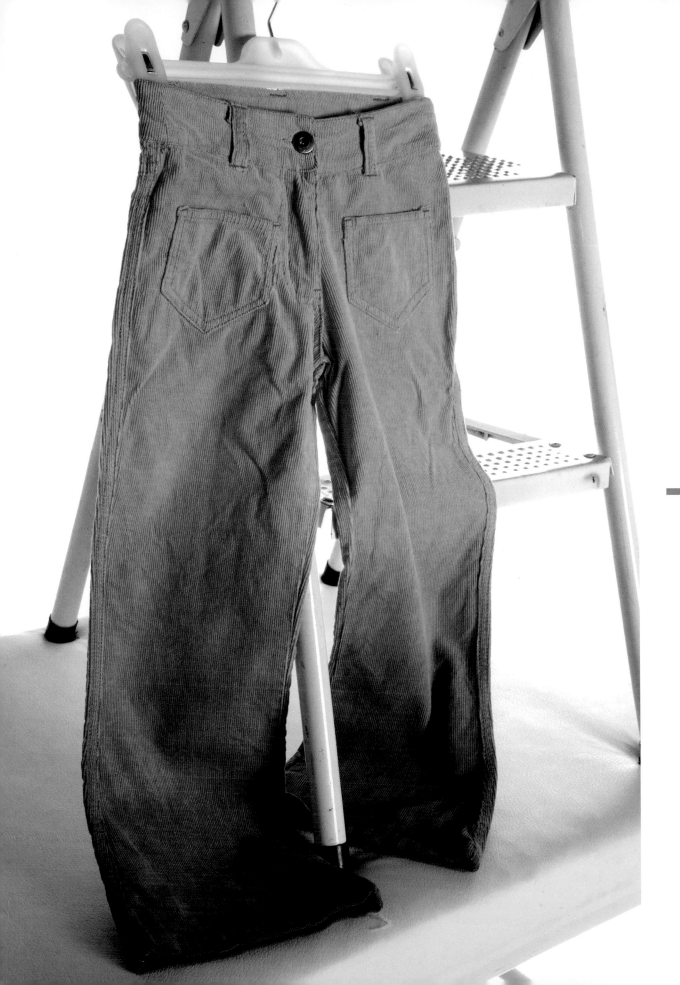

Children's T-shirt in a ball

Crushing a T-shirt into a ball is an easy technique for children and gives great results!

1. Wash and prepare the T-shirt in the usual way (see step 2 on page 23). Crush the fabric into a ball in your hand. Wrap it up with string. Wind string around the bundle in every direction to keep all the folds in place. Pull the string fairly tight. Loop the end under a couple of times to tie it off.

2. Boil the kettle and pour 2 quarts (2 L) water into the bucket. Stir in the dye, the salt and the soda ash and make sure all the lumps are dissolved (this is the All-in method, which is detailed on page 25).

3. Drop the T-shirt into the hot dye immediately. Put the filled water bottle on top of the fabric so it does not float above the surface of the dye. Leave it to stand for 24 hours, rinse in the usual way (see pages 25–27) and dry indoors on a hanger. If you would like to add a second color to dye the resist pattern, simply untie the string and repeat the process with another color.

YOU WILL NEED

100% cotton white children's T-shirt

String

Bucket

Kettle

Purple dye

Salt

Soda ash

Stirring implement

Water bottle filled with water and sealed

crazy patterns

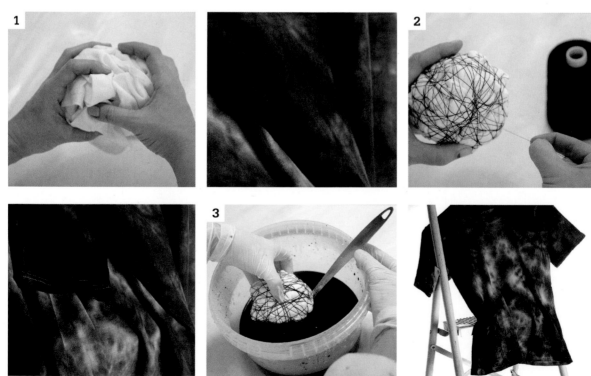

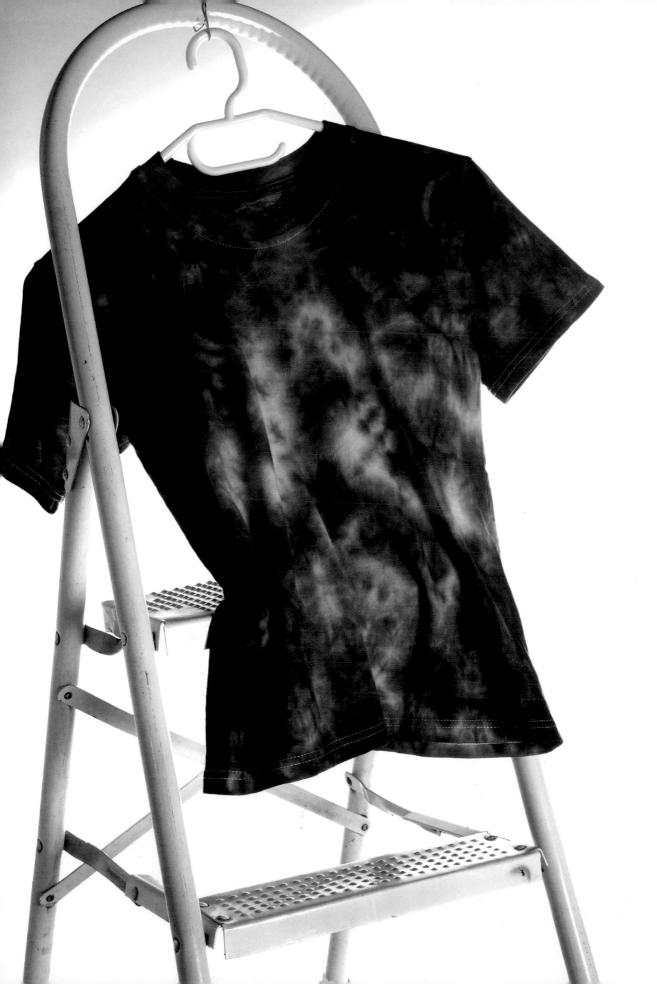

skirt in a ball

Have you picked up a stain on your favorite white skirt? This easy crush technique is a convenient way to hide such a mark and turn your old garment into a fresh fashion statement.

1. Wash and prepare the skirt in the usual way (see step 2 on page 23). Crush it into a ball in your hand. Wrap it up with string. Wind string around the bundle in every direction to keep all the folds in place. Pull the string fairly tight. Loop the end under a couple of times to tie it off.

2. Boil the kettle and pour 2 quarts (2 L) water into the bucket. Stir in the dye, the salt and the soda ash and make sure all the lumps are dissolved (follow the All-in method, detailed on page 25).

3. Drop the skirt into the hot dye immediately. Put the water bottle filled with water on top of the fabric so the skirt does not float above the surface of the dye. Leave it to stand for 24 hours and rinse in the usual way (see pages 25–27).

easy

YOU WILL NEED

100% cotton white skirt

String

Bucket

Kettle

Lime green dye

Salt

Soda Ash

Stirring implement

Water bottle filled with water and sealed

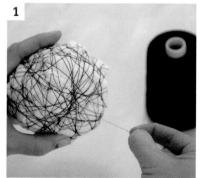

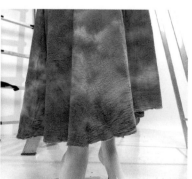

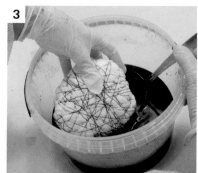

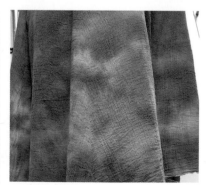

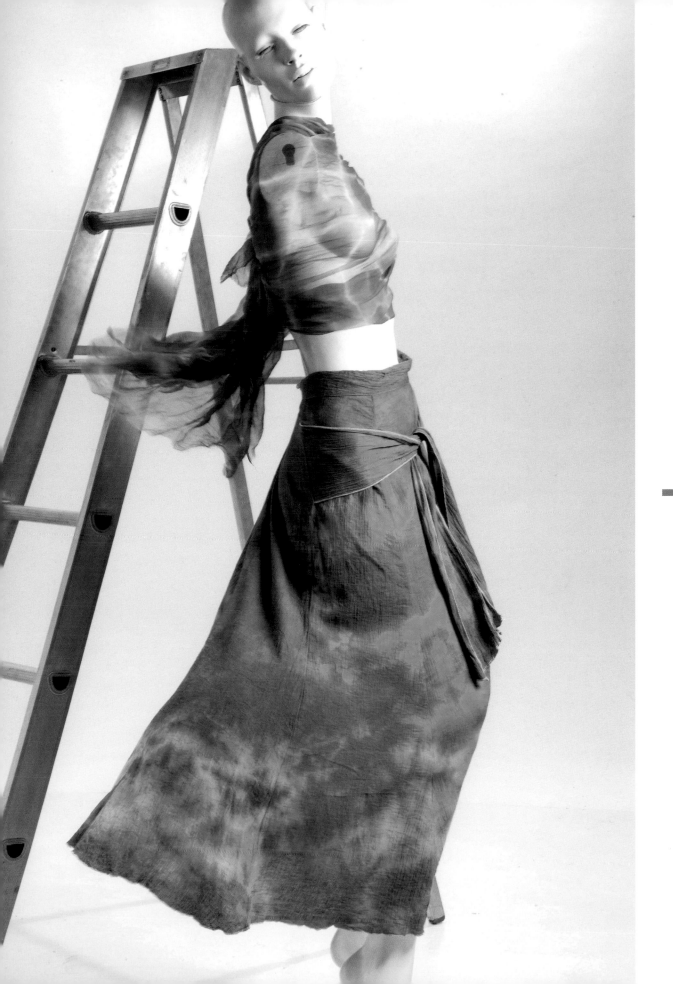

Urban camouflage pants

This is a wonderful technique for turning almost any item into urban camouflage. We are doing this using one color of dye on powder blue corduroy pants.

1. Wash and prepare the pants in the usual way (see page 23). Lay them flat on a clean surface. Place your fingers lightly on the fabric and push it into crumples. Once the whole surface is a crazed landscape, start to wind the string around the bundle, pulling tighter and tighter as you work.

Tip: *The tighter you can wind the string and the firmer the bundle becomes, the clearer and more defined your pattern will be. Try to keep the shape flat and not to let it crumple into a ball. Bunch up the fabric as best you can and then let the string do the rest as you pull it tighter. Once the bundle is firm and secure, loop the end of the string under a couple of times to tie it off so it does not come loose in the dye.*

2. Boil the kettle and pour 2 quarts (2 L) water into the bucket. Stir in the dye, the salt and the soda ash and make sure all the lumps are dissolved (follow the All-in method, detailed on page 25).

3. Drop the pants into the hot dye immediately and jiggle the container for 5 mins. Put the filled water bottle on top of the fabric so it does not float above the surface of the dye. Leave it to stand for 24 hours and rinse in the usual way (see pages 25–27).

easy

YOU WILL NEED

100% cotton light blue pants

String

Bucket

Kettle

Brown dye

Salt

Soda ash

Stirring implement

Water bottle filled with water and sealed

crazy patterns

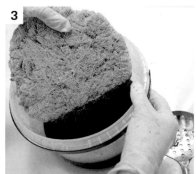

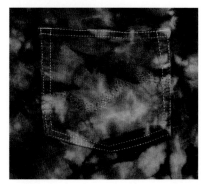

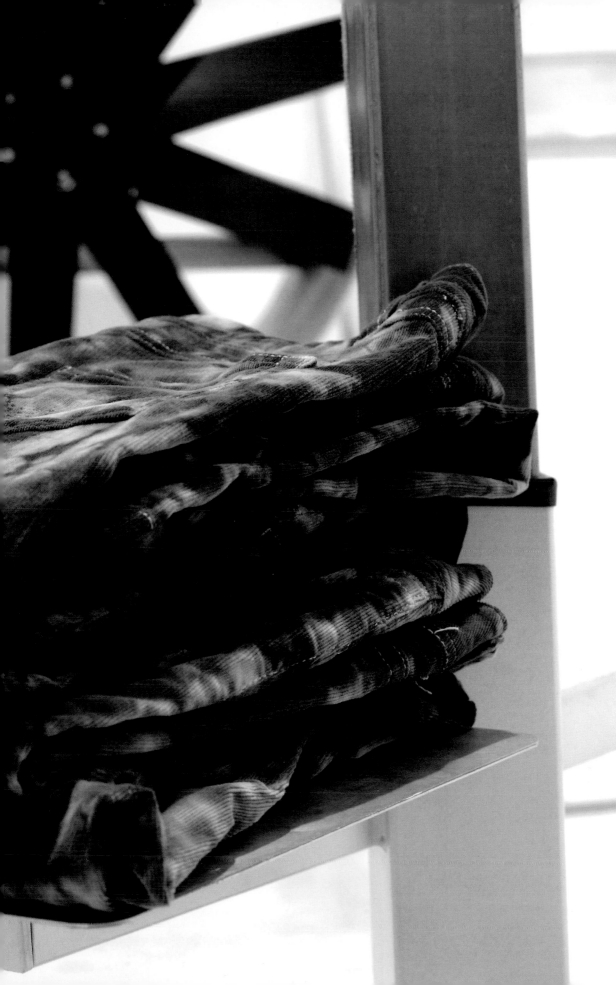

Reverse camouflage T-shirt

The camouflage technique is just as effective using bleach on a black T-shirt.

YOU WILL NEED
100% cotton black T-shirt
String
Bucket
Bleach
Face mask
Goggles
Gloves

1. Wash and prepare the T-shirt in the usual way (see step 2 on page 23). Lay it flat on a clean surface. Place your fingers lightly on the fabric and push it into crumples. Once the whole surface is a crazed landscape, start to wind the string around the bundle, pulling tighter and tighter as you work.

Tip: *The trickiest part is working with the sleeves. Bunch up the fabric as best you can and then let the string do the rest as you pull it tighter. Treat the sleeves as if they are all just part of the same piece of fabric. Pretend they are not there and just keep going.*

2. Once the bundle is firm and secure, loop the end of the string under a couple of times to tie it off so it does not come loose in the bleach. Make sure that the bundle fits into the bottom of your bucket lying flat. If it stands up at an angle because it is too big, find a larger container.

3. Put on your face mask, gloves and goggles. Pour straight bleach into the bottom of the bucket approximately 1/2 inch (1 cm) deep.

4. Place the T-shirt in the bucket and jiggle it around for 30 seconds. Take it out, turn it over, and put it back in to expose the other surface to the bleach. Watch the color start to change. When the color has lightened visibly, plunge the fabric straight into clean cold water and rinse. Keep on rinsing in clean water with a bit of soap until you have washed the smell out completely.

5. Add a little bit of fabric softener to the final rinse. Dry on a coat hanger indoors.

Tip: *If you can still smell the bleach in the fabric, it will continue to eat at the fabric and weaken the fibers enough to cause holes. NEVER walk away from a project like this, the chemical reaction just happens way too fast.*

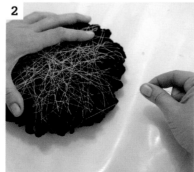

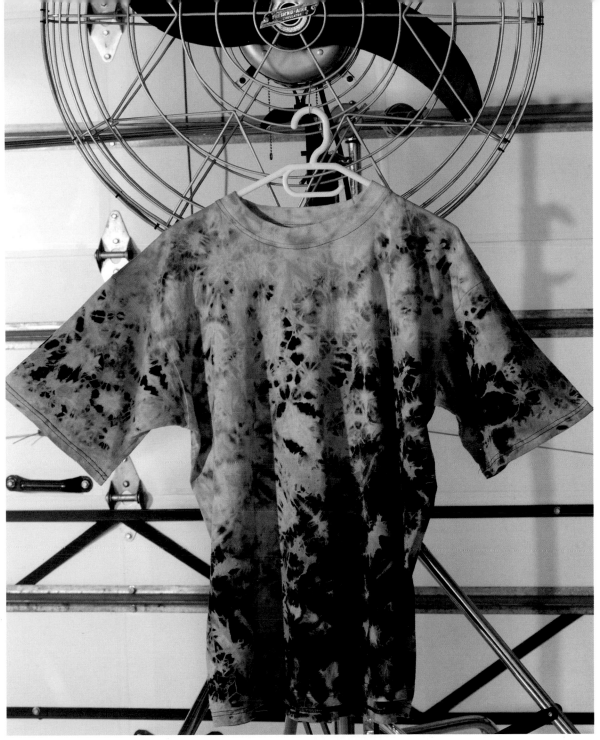

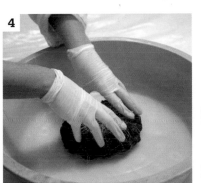

4

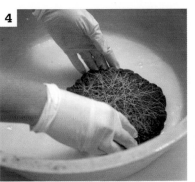

4

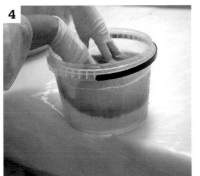

4

Electricity on a T-shirt

Create an eye-catching border on a T-shirt. This one is a favorite with boys, especially if you make it in navy blue.

1. Wash and prepare the T-shirt in the usual way (see page 23). Grab the hem in your hands and gather it together at the same level. Pull the folds straight. Wind an elastic band around the T-shirt, starting about 4 inches (10 cm) from the hem, in an open position (so that the loops are spaced apart). Create a band of elastics 4 inches (10 cm) wide.

Tip: *The tighter you can wind the elastic, the more defined your pattern will be.*

2. Line up the two sleeves over each other and grab the hems in your fist. Gather them evenly across. Wind an elastic band approximately 2 inches (5 cm) from the hem in an open position.

3. Boil the kettle and pour 2 quarts (2 L) water into the bucket. Stir in the dye, the salt and the soda ash and make sure all the lumps are dissolved. Follow the All-in method, detailed on page 25.

4. Drop the T-shirt into the hot dye immediately. Jiggle the bucket vigorously for 5 mins. Put the filled water bottle on top of the fabric so it does not float above the surface of the dye. Leave it to stand for 24 hours and rinse in the usual way (see pages 25–27).

easy

YOU WILL NEED

100% cotton T-shirt

Strong elastic bands

Bucket

Kettle

Navy blue dye

Salt

Soda ash

Stirring implement

Water bottle filled with water and sealed

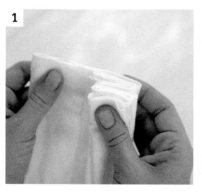

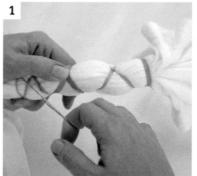

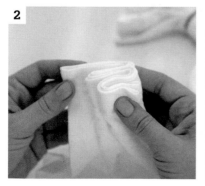

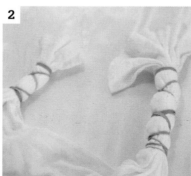

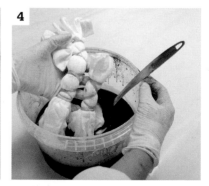

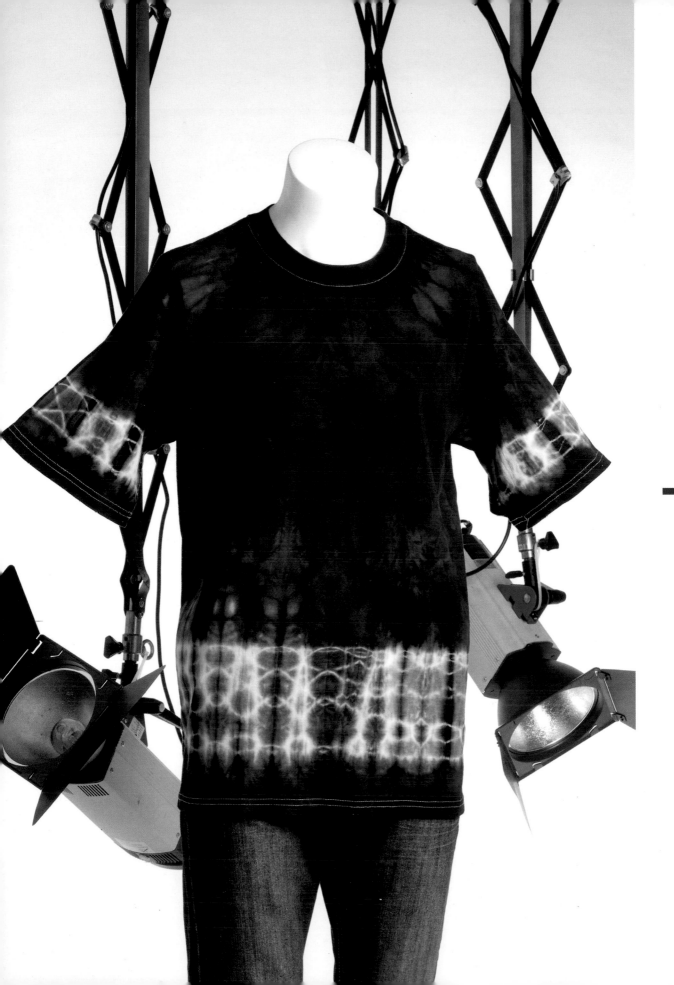

Electricity on a skirt

This technique is effective on any colored cloth. It creates a striking border for a flared skirt.

1. Wash and prepare the skirt in the usual way (see page 23). Grab the hem in your hands and gather it together at the same level. Pull the folds straight. Wind an elastic band around the skirt, starting about 4 inches (10 cm) from the hem, in an open position (with the loops spaced apart). Create a band of elastics 6 inches (15 cm) wide.

Tip: *The tighter you can wind the elastic, the more defined your pattern will be.*

2. Boil the kettle and pour 2 quarts (2 L) water into the bucket. Stir in the dye, the salt and the soda ash and make sure all the lumps are dissolved (follow the All-in method on page 25).

3. Drop the skirt into the hot dye immediately. Jiggle the bucket vigorously for 5 mins. Put the water bottle filled with water on top of the fabric so it does not float above the surface of the dye. Leave it to stand for 24 hours and rinse in the usual way (see pages 25–27).

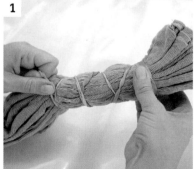

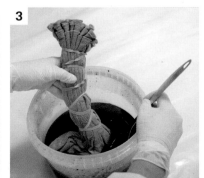

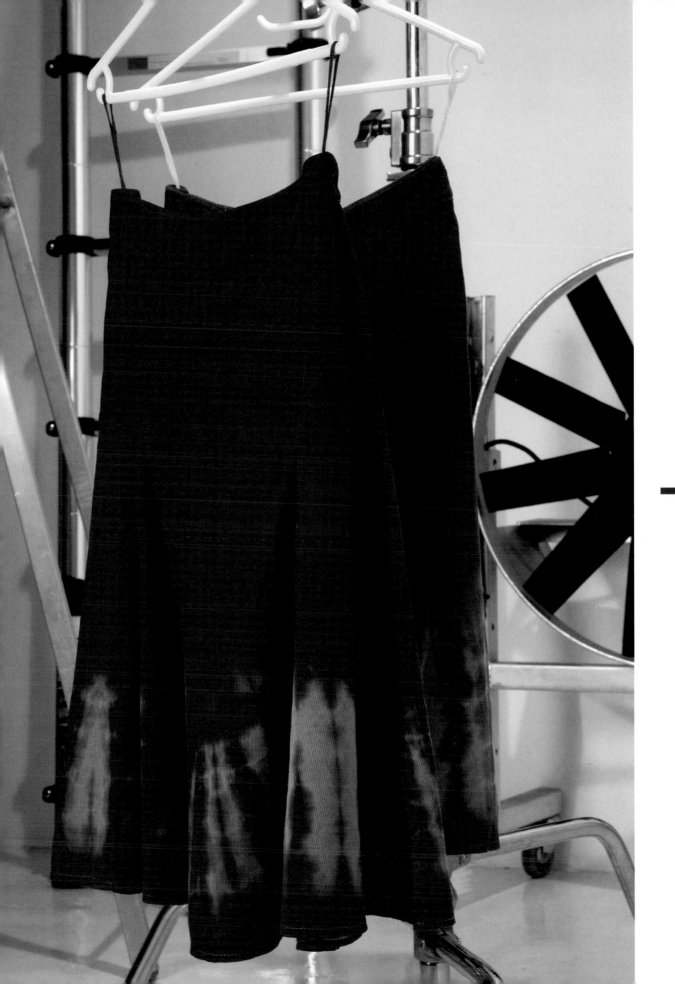

Black-and-white marbled silk

Black and white goes with everything. Make this striking chiffon silk scarf with patience and care. My chiffon silk scarf is my favourite accessory in winter. Silk has the most amazing qualities and you will find it far warmer to wear in winter than you might think. It is lightweight and crumples up into nothing to store in your handbag.

1. Wash and prepare the silk in the usual way (see page 23). Start near the edge. Grab the fabric about 4 inches (10 cm) from the edge and pull a "teat" in the fabric. Stroke the folds straight. Wind an elastic band tightly around the teat, starting about 3/4 inch (2 cm) from the tip, in an open position (so that the loops are spaced apart). Create a band of elastics 6 inches (15 cm) wide.

Tip: *The tighter you can wind the elastic the more defined your pattern will be. If you do not completely restrict the chiffon with the elastics, the pattern will disappear. Chiffon has a very wide weave and requires tight, constricting bindings to create the pattern.*

2. Start approximately 6 inches (15 cm) from the first teat, and repeat the process. Keep tying teats until the whole piece of fabric has been transformed into a squid.

3. Boil the kettle and pour 2 quarts (2 L) water into the bucket. Stir in the dye, the salt and the soda ash and make sure all the lumps are dissolved. Use the All-in method, described on page 25.

4. Drop the silk into the hot dye immediately. Jiggle the bucket vigorously for 2 mins. Put the filled water bottle on top of the fabric so the scarf does not float above the surface of the dye. Leave it to stand for 1 hour and rinse in the usual way (see pages 25–27). You will notice that the silk needs considerably less rinsing than cotton. Add some fabric softener to your final rinse.

Tip: *Undo the elastic bands only once the rinsing water is clean. Do not use scissors to cut them loose – it is very easy to cut the delicate fabric because the elastics are so tight. You will need the same patience to untie this project as it took to bind it in the first place.*

YOU WILL NEED

2 yards (2 m) white chiffon silk

Many strong elastic bands

Bucket

Kettle

Black dye

Salt

Soda ash

Stirring implement

Water bottle filled with water and sealed

crazy patterns

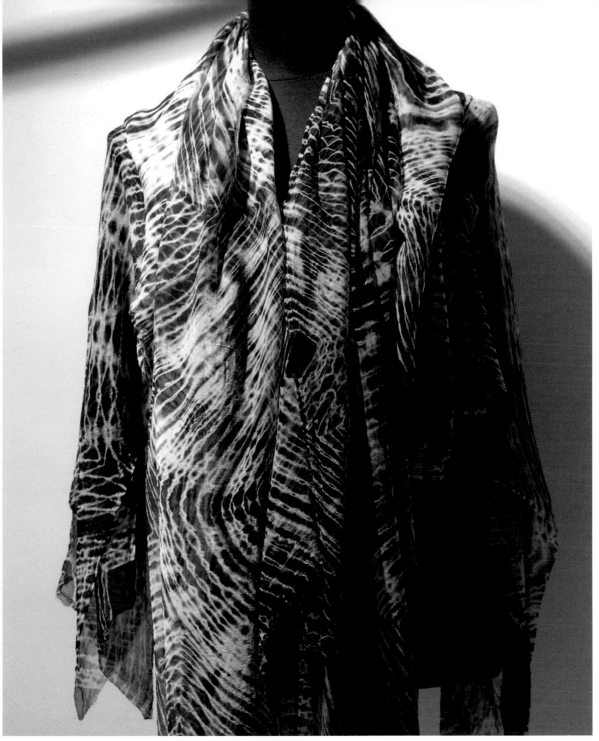

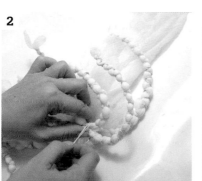

2

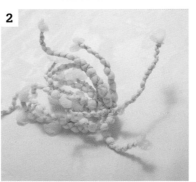

2

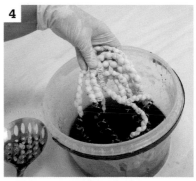

4

Water fantasy silk

Bind the fabric in the same way as in Black-and-White Marbled Silk (see pages 50–51), and change the color. See how it transforms your chiffon-silk scarf into an underwater fantasy. You will be the envy of all your friends when you wear it.

1. Wash and prepare the silk in the usual way (see page 23). Start near the edge. Grab the fabric about 4 inches (10 cm) from the edge and pull a "teat" in the fabric. Stroke the folds straight. Wind an elastic band tightly around the teat, starting about 3/4 inch (2 cm) from the tip, in an open position (so that the loops are spaced apart). Create a band of elastics 6 inches (15 cm) wide.

2. Start approximately 6 inches (15 cm) from there, and repeat the process. Keep tying teats until the whole piece of fabric resembles a squid.

3. Boil the kettle and pour 2 quarts (2 L) of water into the bucket. Stir in the turquoise dye, the salt and the soda ash and make sure all the lumps are dissolved, as outlined in the All-in method on page 25.

Tip: *Experiment with containers before you start. Find one that is small enough that you can perch the "squid" in the dye with either just the tentacles in the fluid, or just the body. I find if I use a narrow 2 quart (2 L) bucket it holds all the bits in place.*

4. Pour approximately 2 inches (5 cm) of hot dye into the bucket. Prop the "squid" into the bucket with its tentacles in the hot dye. Leave it to stand for half an hour.

5. Boil the kettle and pour 2 quarts (2 L) of water into the bucket. Stir in the navy dye, the salt and the soda ash and make sure all the lumps are dissolved. Pour approximately 2 inches (5 cm) of hot navy dye into the bucket. Prop the "squid" into the bucket with its body in the hot dye. Leave it to stand for an hour.

6. Rinse in the usual way (see pages 25–27). You will notice that the silk needs considerably less washing than cotton. Only undo the elastic bands before the final rinse. Add fabric softener to the last rinse.

intermediate

YOU WILL NEED

2 yards (2 m) white chiffon silk

Many strong elastic bands

2 buckets

Kettle

Turquoise and navy dye

Salt

Soda ash

Stirring implement

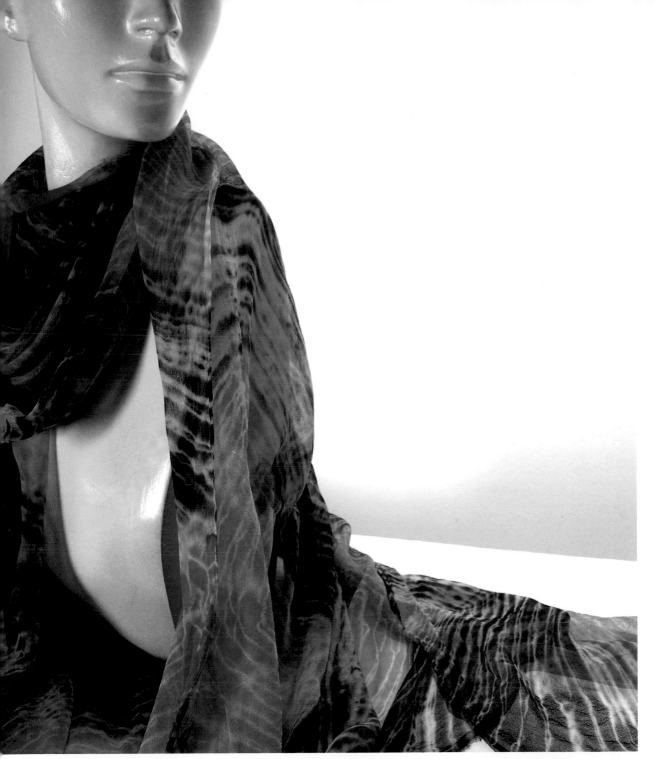

4

4

5

Sunburst T-shirt

Bleach a black T-shirt to create a striking focal point. Work fast to ensure the success of this technique.

1. Wash and prepare the T-shirt in the usual way (see page 23). Work with it damp. Lay it flat on the table. Find and mark the visual center of the shirt with chalk. Grab the center with your thumb and forefinger to make a "teat."

Tip: *Make sure you grip both layers of the fabric. You want the pattern on both sides of the shirt.*

2. Wind a strong elastic band tightly around the teat in an open position (with the loops spaced apart), starting approximately 3/4 inch (2 cm) from the tip.
3. Put on your face mask, gloves and goggles. Pour straight bleach into the yogurt container approximately 2 inches (5 cm) deep. Dip the teat in the bleach and give it a jiggle. Remove it and lay the shirt flat on a clean, flat surface outside and smooth out as many creases as possible. Suck up the bleach into the syringe. Squirt it gently onto the fabric in stripes, starting at the teat in the center, and moving outward toward the edge of the shirt to create rays.
4. Watch the color start to change. When the color has lightened visibly, plunge the fabric straight into clean cold water and rinse. Keep on rinsing in clean water with a bit of soap until you have washed the smell out completely. Add a little bit of fabric softener to the final rinse. Dry on a coat hanger indoors.

bleach

YOU WILL NEED
100% cotton black T-shirt
Strong elastic bands
Chalk
Yogurt container
Syringe
Bleach
Face mask
Goggles
Gloves

crazy patterns

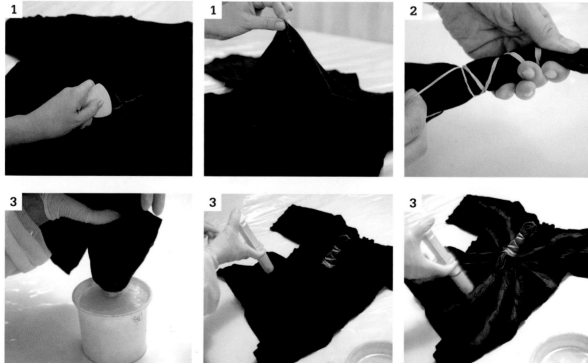

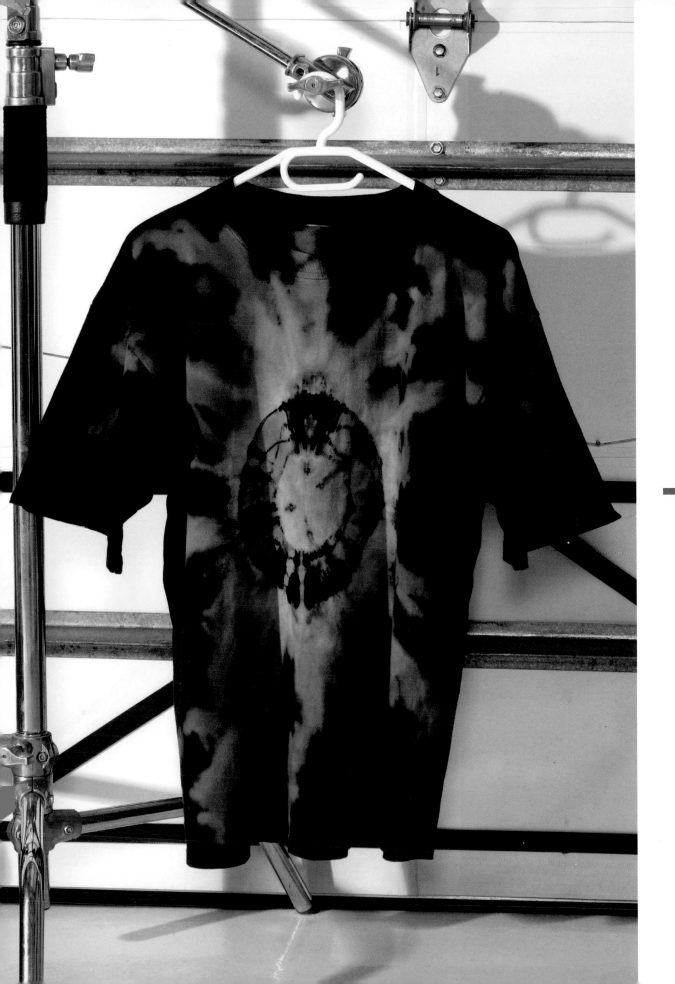

Coral stretch decor

Children love an underwater fantasy. Yours will be the envy of all their friends with this imaginative creation. Suspend the stretch fabric like a canopy using a hammer and nails to mount it.

1. Wash and prepare the fabric in the usual way (see page 23). Start near the edge. Grab the fabric about 4 inches (10 cm) from the edge and pull a "teat" in the fabric. Stroke the folds straight. Wind an elastic band tightly around the teat, starting about 2 inches (5 cm) from the tip, in an open position (so that the loops are spaced apart). Create a band of elastics 2 inches (5 cm) wide.

Tip: *The tighter you can wind the elastics, the more defined your pattern will be.*

2. Start approximately 6 inches (15 cm) from there, and repeat the process. Keep tying teats side-to-side until the whole piece of fabric has been transformed into coral.

3. Boil the kettle and pour 2 quarts (2 L) water into a bucket. Stir in the turquoise dye, the salt and the soda ash and make sure all the lumps are dissolved (follow the All-in method for this on page 25). Place the fabric in a separate bucket. Pour the dye over the fabric and jiggle the bucket for 5 mins.

4. Boil the kettle and pour 2 quarts (2 L) water into the mixing bucket. Stir in the navy dye, the salt and the soda ash and make sure all the lumps are dissolved. Pour the navy dye over the top of everything. Submerge the fabric under the surface of the liquid using the filled water bottles as weights.

Tip: *Where the fabric floats above the surface of the liquid, it makes a mark that is distinctive on the finished work. Using sinkers eliminates this problem.*

5. Leave it to stand for 24 hours and then rinse in the usual way (as detailed on pages 25–27). Only undo the elastic bands before the final rinse. Add fabric softener to the last rinse.

Tip: *For an interesting effect, cut out the center circles of some patterns before draping the fabric.*

advanced

YOU WILL NEED

2 yards (2 m) 100% cotton light blue fabric

Many strong elastic bands

2 buckets

Kettle

Turquoise and navy dye

Salt

Soda ash

Stirring implement

Water bottles filled with water and sealed

Hammer and nails (to mount)

crazy patterns

1

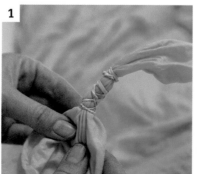

1

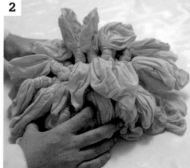

2

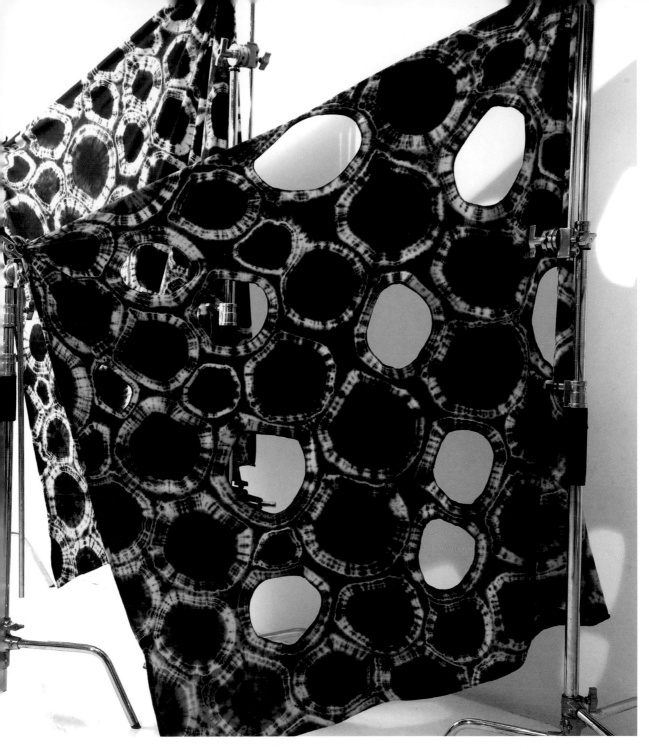

3

3

4

Cobweb T-shirt

Create these novelty T-shirts for Halloween and move to the top of your children's list of favorite people.

1. Wash and prepare the T-shirt in the usual way (see page 23). Look at your T-shirt through squinted eyes and decide approximately where you want to see the cobwebs on the finished garment. Mark the centers with chalk.

2. Cut a piece of string 10–14 inches (25–35 cm) long. Grab the fabric between thumb and forefinger on one of the marks that you made. Starting about 1/2 inch (1 cm) from the tip, wind the string in a tight spiral, down the length into a "teat." The tighter you wind the string, the more defined your pattern will be.

3. When you get near the end of the string, loop it under twice so it does not come loose in the dye. Repeat the process until you have made all the cobwebs that you want. Do not be afraid to work off the edge of the fabric.

Tip: *Shapes that spill off the edge of the fabric give the garment a dynamic, spontaneous look.*

4. Boil the kettle and pour 2 quarts (2 L) of water into the bucket. Stir in the dye, the salt and the soda ash and make sure all the lumps are dissolved (use the All-in method on page 25).

5. Drop the T-shirt into the hot dye immediately. Jiggle the bucket vigorously for 5 mins. Put the water bottle on top of the fabric so it does not float above the surface of the dye. Leave it to stand for 24 hours and rinse (see pages 25–27).

easy

YOU WILL NEED

100% cotton white T-shirt

String

Scissors

Chalk

Bucket

Kettle

Black dye

Salt

Soda ash

Stirring implement

Water bottle filled with water and sealed

2

2
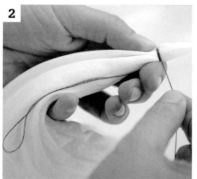

3
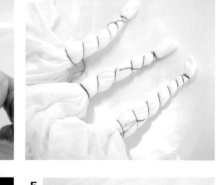

3
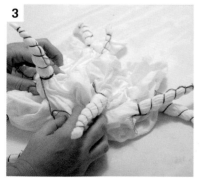

5

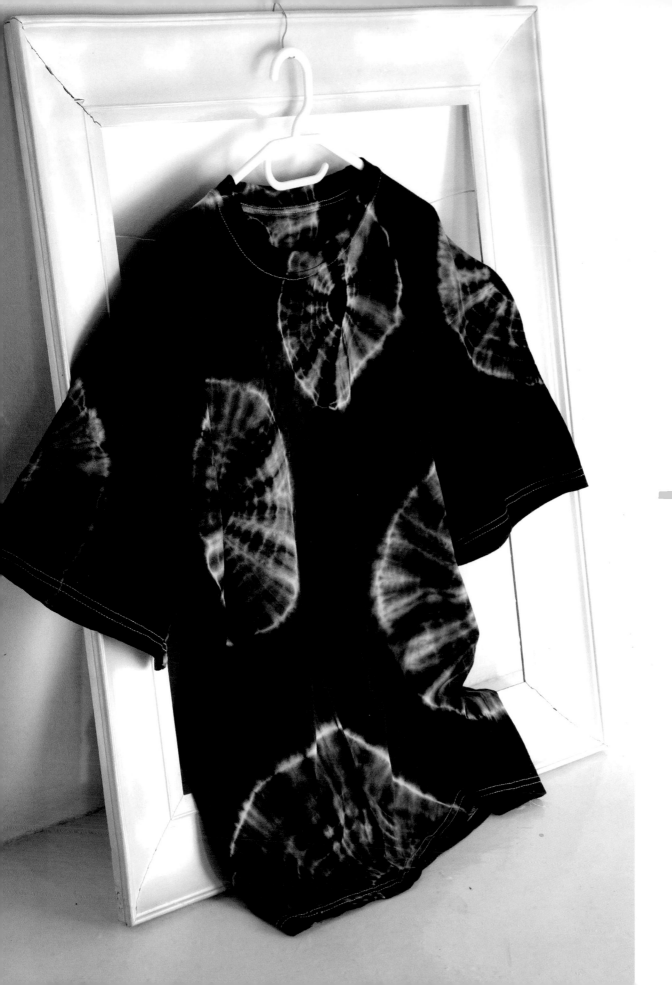

Cobwebs stretch decor

Some kids just love the novelty of Halloween. Do up their rooms for the event with some funky stretch decor.

1. Wash and prepare the fabric in the usual way (see page 23). Look at your fabric through squinted eyes and decide approximately where you want to see the cobwebs on the finished piece. Mark the centers with chalk.

2. Cut pieces of string 10–14 inches (25–35 cm) long. Grab the fabric between thumb and forefinger on one of the marks that you made. Starting about 1/2 inch (1 cm) from the tip, wind the string in a very tight spiral, down the length into a "teat." The tighter you can wind the string, the more defined your pattern will be.

3. When you get near the end of the string, loop it under twice so it does not come loose in the dye. Repeat the process until you have made all the cobwebs that you want to see. Do not be afraid to work off the edge of the fabric. Pretend it is continuous and just keep going.

4. Boil the kettle and pour 2 quarts (2 L) of water into the bucket. Stir in the dye, the salt and the soda ash and make sure all the lumps are dissolved (follow the All-in method on page 25).

5. Drop the fabric into the hot dye immediately. Jiggle the bucket vigorously for 5 mins. Put the water bottle on top of the fabric so it does not float above the surface of the dye. Leave it to stand for 24 hours and rinse in the usual way (see pages 25–27).

intermediate

YOU WILL NEED

2 yards (2 m) 100% cotton gray fabric

String

Scissors

Chalk

Bucket

Kettle

Black dye

Salt

Soda ash

Stirring implement

Water bottle filled with water and sealed

crazy patterns

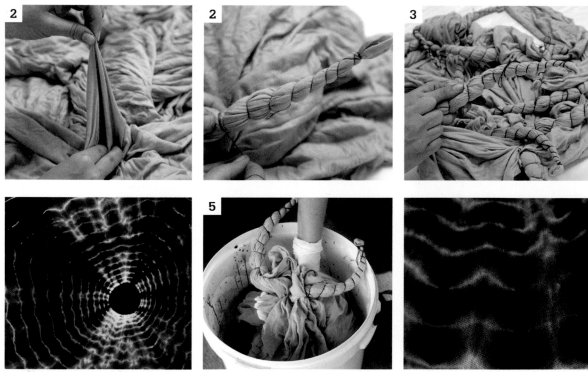

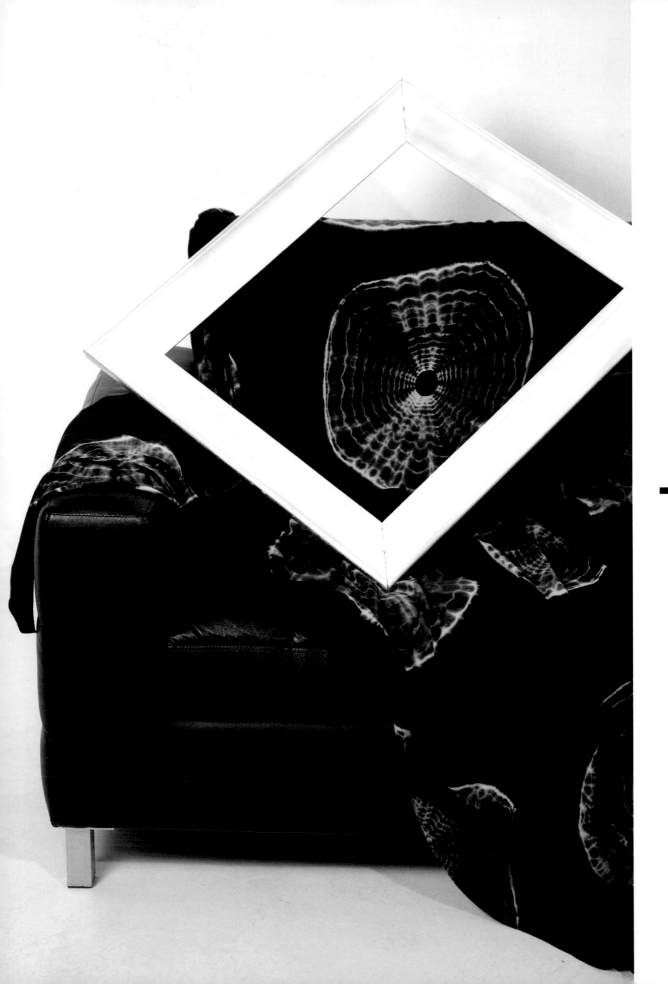

Flowers on a skirt

Round shapes create a striking border on a skirt. The polyester embroidered detail on this ready-made garment creates a striking contrast on the finished item. Polyester stitching will not absorb dye. This can be a challenge, or you can turn it into a feature.

1. Wash and prepare the skirt in the usual way (see page 23). Plan how you would like to place the shapes and draw them onto the fabric with chalk. Mark the centers of the shapes, as well as the edges. Space them evenly all around the hem of the skirt.

2. Pull the fabric into a "teat" by grabbing a marked center between your thumb and forefinger. Starting 2 inches (5 cm) from the tip, wrap an elastic band very tightly in an open position (with the loops spaced apart). Create a band about 2 inches (5 cm) wide. Move on to the next shape and repeat. Work around the hem of your skirt until you have created a border all around.

3. Boil the kettle and pour 2 quarts (2 L) water into the bucket. Stir in the dye, the salt and the soda ash and make sure all the lumps are dissolved (follow the All-in Method on page 25).

4. Drop the skirt into the hot dye immediately. Jiggle the container vigorously for 5 mins. Put the filled water bottle on top of the fabric so it does not float above the surface of the dye. Leave it to stand for 24 hours and rinse in the usual way (as detailed on pages 25–27).

crazy patterns

easy

YOU WILL NEED

100% cotton white skirt

Strong elastic bands

Chalk

Bucket

Kettle

Orange dye

Salt

Soda ash

Stirring implement

Water bottle filled with water and sealed

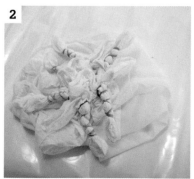

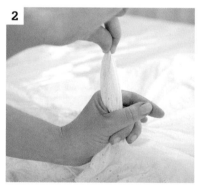

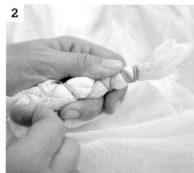

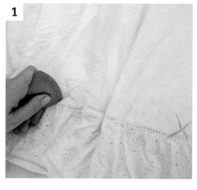

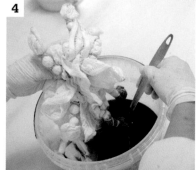

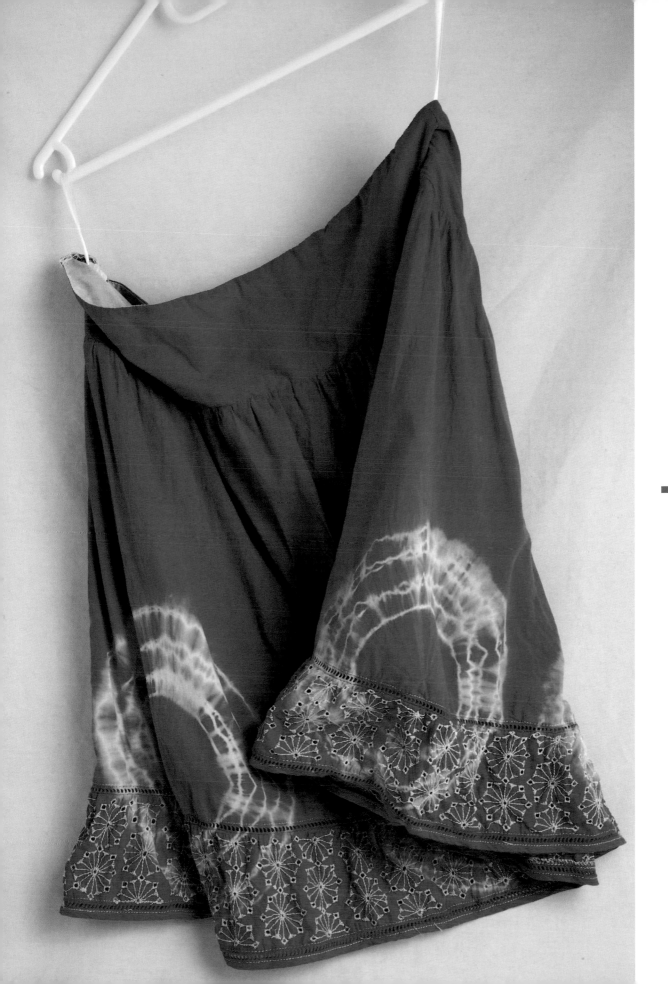

contemporary dyecraft

spotted onesies

The technique used to make these onesies in single colors is easy enough for children to do.

1. Wash and prepare the pajamas in the usual way (see step 2 on page 23). Pull the fabric into a "teat" and wrap an elastic band very tightly in a closed position (looped to form a solid band) approximately 2 inches (5 cm) from the tip. The elastic band must be very tight. Move on to the next shape and do the same. Place these circles at evenly spaced intervals all over the garment. Do not be afraid to work the shapes off the edge of the fabric. Make sure that you cover the whole garment evenly.

2. Boil the kettle and pour 2 quarts (2 L) water into the bucket. Stir in the dye, the salt and the soda ash and make sure all the lumps are dissolved. Follow the All-in method detailed on page 25.

3. Drop the pajamas into the hot dye immediately. Jiggle the container vigorously for 5 mins. Put the filled water bottle on top of the fabric so it does not float above the surface of the dye. Leave it to stand for 24 hours and rinse in the usual way (as outlined on pages 25–27).

easy

YOU WILL NEED

100% cotton onesie(s)

Strong elastic bands

Bucket

Kettle

Pink or blue dye

Salt

Soda ash

Stirring implement

Water bottle filled with water and sealed

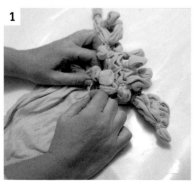

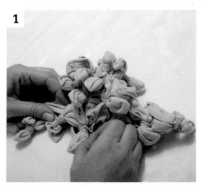
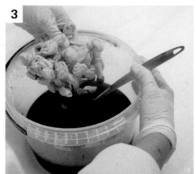

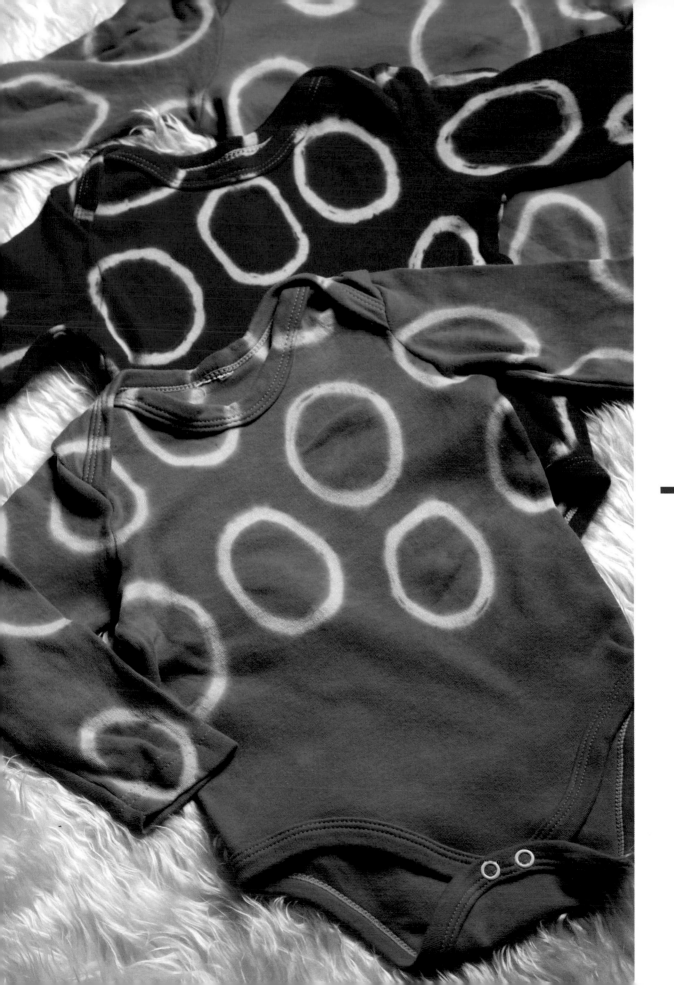

Concentric circles T-shirt

Create a striking target on a T-shirt with this classic design.

easy

1. Wash and prepare the T-shirt in the usual way (see step 2 on page 23). Grab the fabric in the center of the chest and pull it into a "teat" shape. Make sure to grip both layers of fabric firmly in your fingers. Starting 2 inches (5 cm) from the tip, wrap an elastic band very tightly in a closed position (so that it is looped to form a solid band). Move down the shape and bind another elastic band tightly in a closed position 2 inches (5 cm) from the first one. Add closed elastic bands at 2 inch (5 cm) intervals all the way along the shirt.

2. Boil the kettle and pour 2 quarts (2 L) water into the bucket. Stir in the dye, the salt and the soda ash and make sure all the lumps are dissolved. Follow the All-in method outlined on page 25.

3. Drop the T-shirt into the hot dye immediately. Jiggle the container vigorously for 10 mins. Put the filled water bottle on top of the fabric so it does not float above the surface of the dye. Leave it to stand for 24 hours and rinse in the usual way (as detailed on pages 25–27).

YOU WILL NEED

100% cotton white T-shirt

Strong elastic bands

Bucket

Kettle

Orange dye

Salt

Soda ash

Stirring implement

Water bottle filled with water and sealed

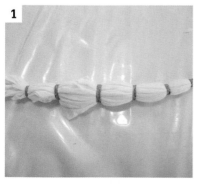

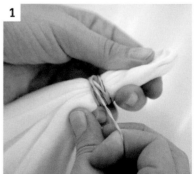

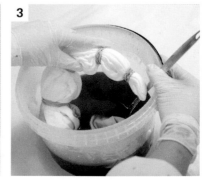

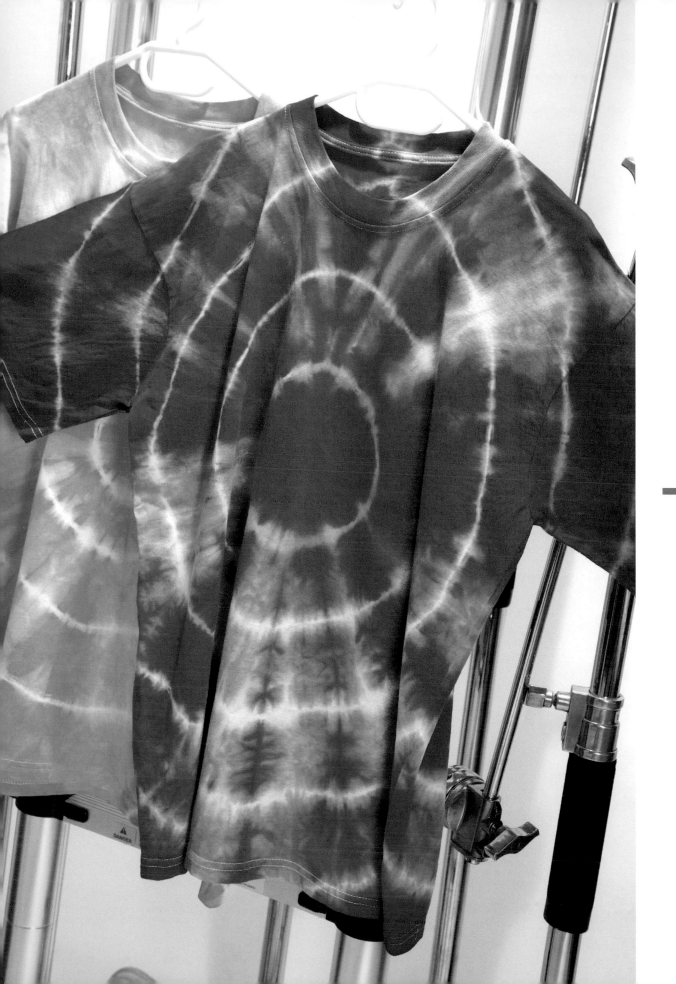

Incomplete circles

Create a bold pattern on a girl's long-sleeved shirt using two elastic bands.

1. Wash and prepare the shirt in the usual way (see step 2 on page 23). Give it a good shake, lay it on a table and smooth out all the creases. Fold the shirt down the center. Line up the hem and sleeves perfectly. Grip the fabric where the sleeve joins the body in the armpit. Lift up the shirt. This causes the fold of fabric to drape down in a teat shape. Bind a very strong elastic band in a closed position (looped to form a sholid band) approximately 6 inches (15 cm) from the tip. Add another 2 inches (5 cm) along from that.

2. Boil the kettle and pour 2 quarts (2 L) water into the bucket. Stir in the dye, the salt and the soda ash and make sure all the lumps are dissolved. Follow the All-in method on page 25.

3. Drop the shirt into the hot dye immediately. Jiggle the container vigorously for 5 mins. Put the filled water bottle on top of the fabric so it does not float above the surface of the dye. Leave it to stand for 24 hours and rinse in the usual way (as outlined on pages 25–27).

YOU WILL NEED

100% cotton long-sleeved shirt

2 strong elastic bands

Bucket

Kettle

Navy blue dye

Salt

Soda ash

Stirring implement

Water bottle filled with water and sealed

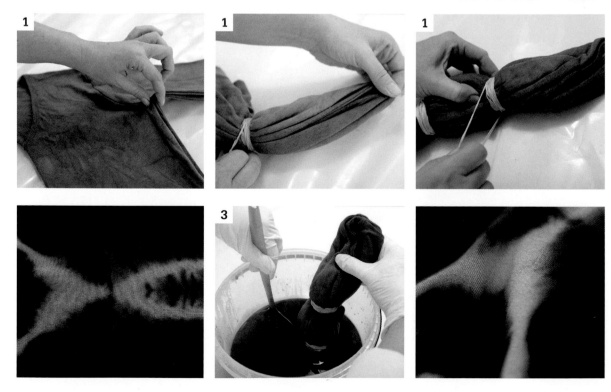

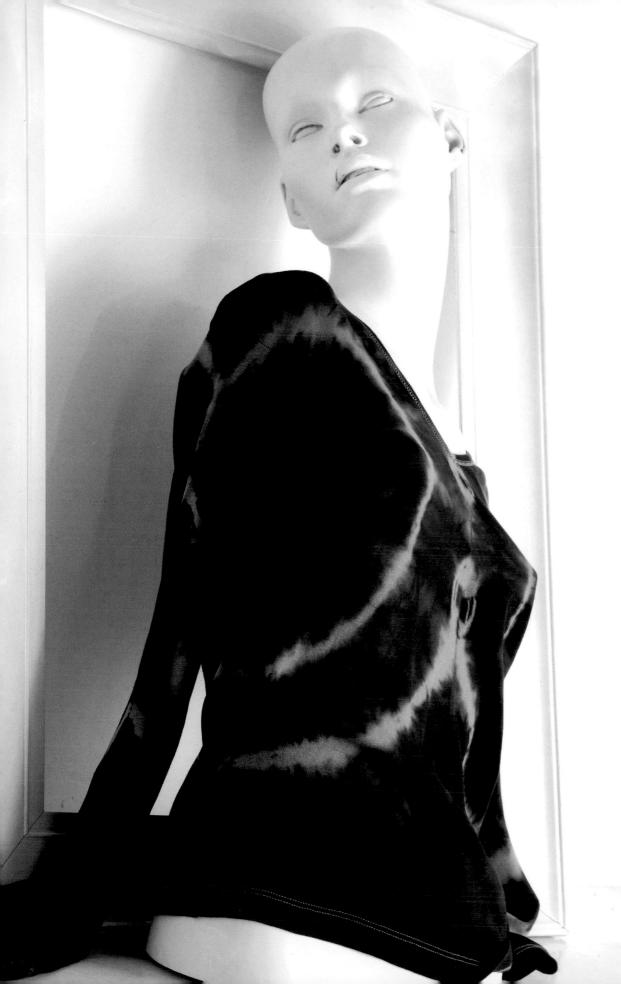

Target with epaulettes

Why not create some stunning focal points? Try out this easy one-color shirt. If you start with a colored base cloth, you end up with a bold two-color result.

1. Wash and prepare the shirt in the usual way (see step 2 on page 23). Give it a good shake, lay it on a table and smooth out all the creases.

2. Squint your eyes and picture where the center of the chest is. Grip only the top layer of fabric between your thumb and forefinger and lift the shirt up. The fabric will drape downward in creases. Pull the fabric into a "teat." Bind an elastic band very tightly in a closed position (looped to form a solid band) 3/4 inch (2 cm) from the tip. Add another 1 inch (3 cm) away from the first teat and a third one 1 inch (3 cm) away from the second. Create the same kind of shape on each shoulder using only 2 bands.

3. Boil the kettle and pour 2 quarts (2 L) water into the bucket. Stir in the dye, the salt and the soda ash and make sure all the lumps are dissolved. Follow the All-in method on page 25.

4. Drop the shirt into the hot dye immediately. Jiggle the container vigorously for 5 mins. Put the filled water bottle on top of the fabric so it does not float above the surface of the dye. Leave it to stand for 24 hours and rinse in the usual way (as outlined on pages 25–27)

easy

YOU WILL NEED

100% cotton yellow long-sleeved shirt

Strong elastic bands

Bucket

Kettle

Turquoise dye

Salt

Soda ash

Stirring implement

Water bottle filled with water and sealed

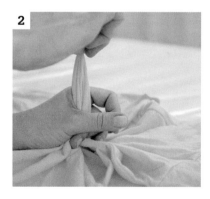
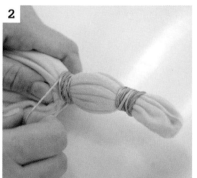
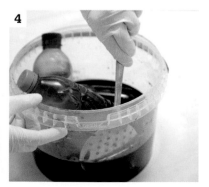

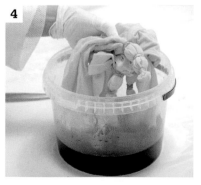
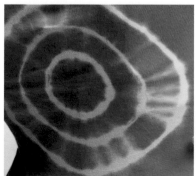
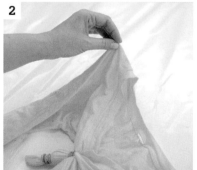

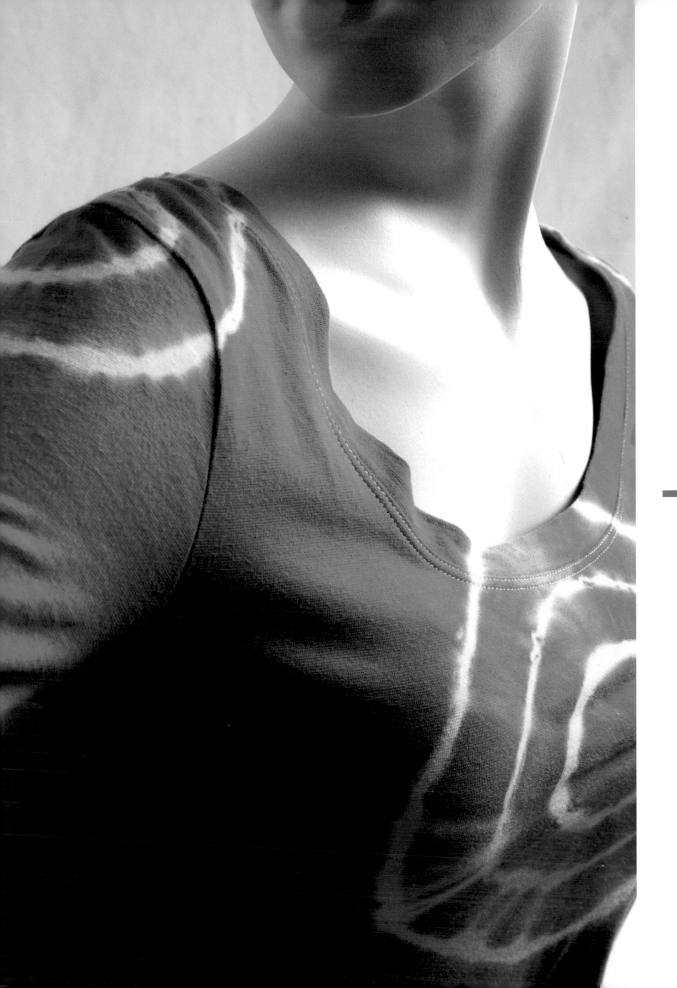

Three-color target with epaulettes

This tie-dye has a dramatic psychedelic look. It is an advanced technique in three colors.

1. Wash and prepare the shirt in the usual way (see page 23). Give it a good shake, lay it on a table and smooth out all the creases.

2. Squint your eyes and picture where the center of the chest is. Grip only the top layer of fabric between your thumb and forefinger and lift the shirt up. The fabric will drape downward in creases. Pull the fabric into a "teat." Bind an elastic band very tightly in a closed position (looped into a solid band), 3/4 inch (2 cm) from the tip. Add another 1 inch (3 cm) away from the first teat and a third 1 inch (3 cm) away from the second. Create the same kind of shape on each shoulder, using only two bands.

3. Mix two packets of soda ash in 2 quarts (2 L) hot water in a bucket and stir out all the lumps. Put the shirt in the bucket to soak for an hour. Take it out, squeeze out as much of the moisture as you can, and leave it to drain on the wire rack for half an hour.

4. Pour 2 quarts (2 L) hot water into each of the three remaining buckets. Stir in the dye (one colour in each bucket) and then the salt and make sure all the lumps are dissolved.

5. Lay the garment on the cooling rack with the teats all facing in one direction. Perch the cooling rack over a basin or stainless steel sink to catch the run-off.

Tip: *Work fast.*

YOU WILL NEED

100% cotton white long-sleeved shirt

Strong elastic bands

4 buckets

Gold, red and navy dye

Salt

Soda ash

Stirring implement

Large syringe or squeeze bottle

Wire shelf or drying rack

3 recycled plastic bags

Large bowl

Microwave oven

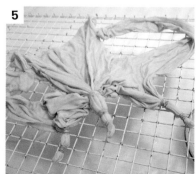

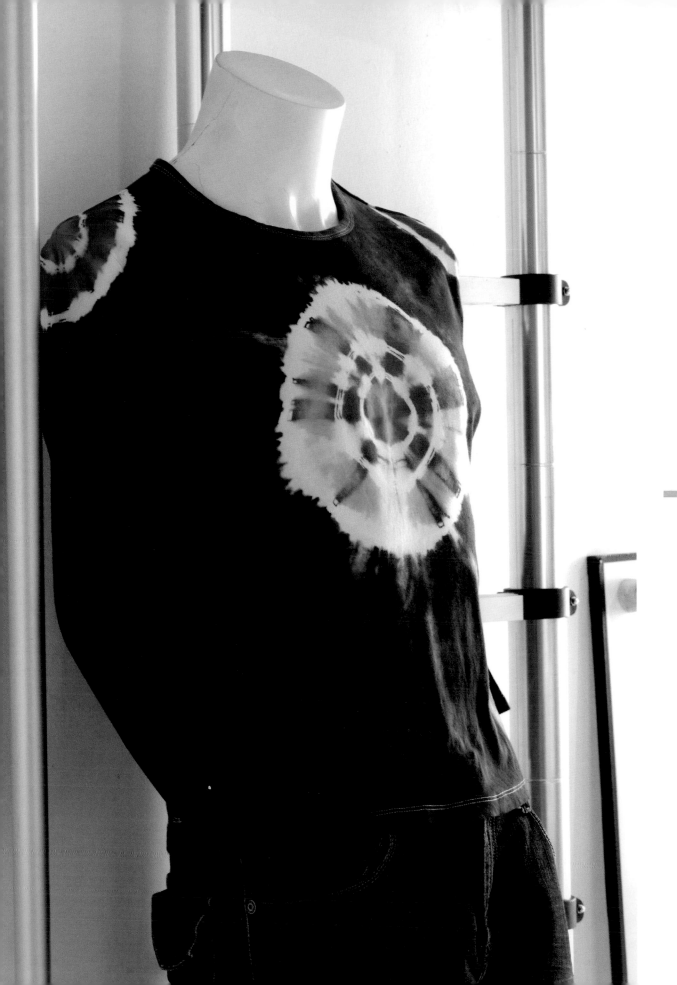

6. Draw up the first color into the syringe and squirt it onto the teats. Work the color into the fibers with the pressure from the syringe. If you do not want a lot of white on your project, squirt on twice as much dye as you think is necessary. It is a physical and a chemical process. The dye must be pushed into the fibers for it to take to the fabric.

7. Move on to the second color and apply it only to the second band below the tips.

8. Finally, work with the third color and cover the body of the shirt. Do not be afraid to move the project around to get at it from all angles. Go back and run more of the lighter colors onto the fabric where it has been swallowed up by the darker colors. I always give the lightest color a final flush at the end to keep it fresh and bright.

9. Place the shirt in a plastic bag with all the teats facing in one direction. Press the air out of the bag and twist the top shut. Place this bag in a second one. Press out the air and twist the top. Place this in a third bag and do the same. Place the whole thing in a large bowl in your microwave. (See page 25 for details on dyeing in the microwave.)

10. Heat the bundle until steaming hot. The period of time will depend on the size of the garment. The setting will depend on the power of your microwave. I prefer to err on the side of caution. I put the bundle in the oven for 5 mins on medium high. When the time is up, I take it out and feel it all around. If it is hot throughout it is ready. If it is cold on one side, I put it back in for another 5 mins. Take care, as the fabric can burn or catch fire in the microwave if it dries out.

11. When it is hot throughout, wrap it in a few layers of newspaper or place it in a warm place and leave it to stand for 24 hours. Rinse it in the usual way (follow the directions on pages 25–27).

Tip: *The dye must remain moist for the reaction to work, so we want to keep the moisture in the bag. If you tie a knot in the bag, it tends to burst (it gives me a scare every time). If it is in three bags, the steam remains trapped inside with the fabric. The bowl is there to catch whatever dye leaks out. The fluid is corrosive and you do not want it in the working parts of your microwave.*

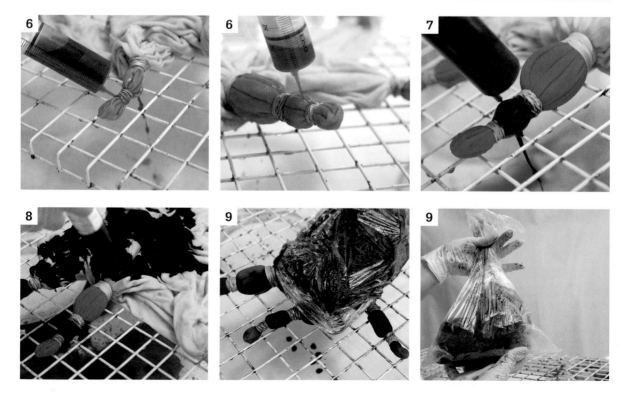

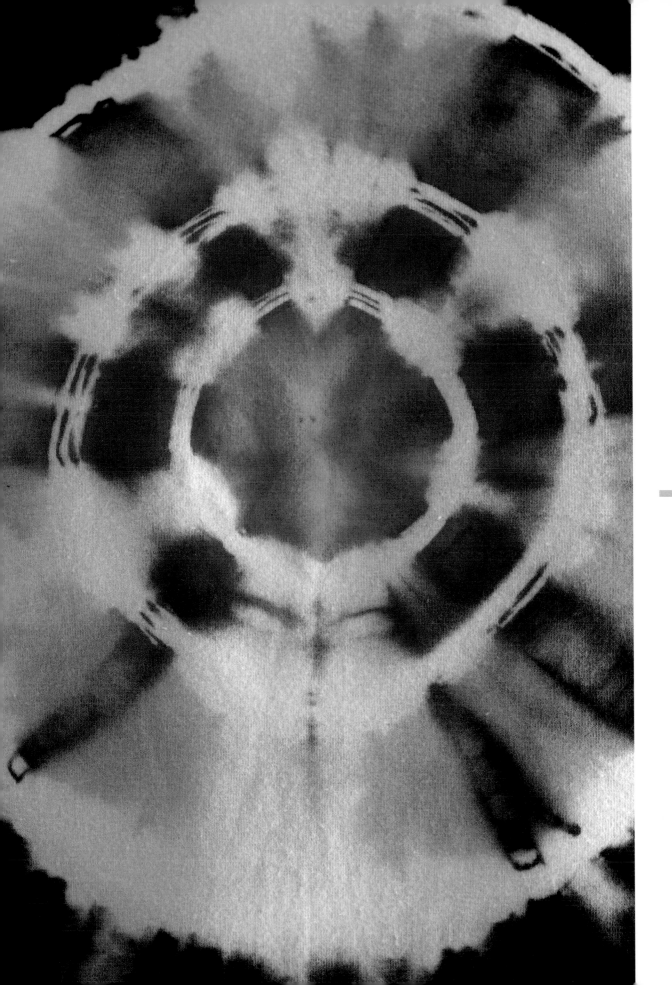

Black-and-white striped silk

Stripes are always chic. Create some on an elegant scarf for autumn. This finish in black and white will compliment any black suit.

1. Wash and prepare the fabric in the usual way (see page 23).

2. Grip the fabric along the cut edge and create evenly spaced gathers. Smooth the folds evenly lengthways and lay the "sausage" on the table. Gently wrap it up with string down the length. The string should not be tight. It is simply a loose loop created to hold the shape together.

3. Wrap the sausage loosely around your hand to create a coil. Wrap the coils in place with string. Again, it should not be tight enough to constrict the fabric and make a mark. It is there to hold the bound shape in place.

4. Place the coil inside an empty bucket and check how much dye you need to pour in to make the liquid come up to the halfway mark on the coil. Do this before you mix the dye so that you have time to think and plan clearly. Take out the coil.

5. Boil the kettle and pour 2 quarts (2 L) water into the other bucket. Stir in the dye, the salt and the soda ash and make sure all the lumps are dissolved. Pour the planned quantity of dye into the empty bucket and place the coil in the dye. The mixture should reach the halfway level on the coil. Jiggle the container lightly for a minute and place it aside to stand for one hour.

6. Rinse off the first excess under a running tap and then continue rinsing in the usual way (see pages 25–27).

easy

YOU WILL NEED

2 yards (2 m) white chiffon silk

String

Two 2-quart (2-L) buckets

Kettle

Black dye

Salt

Soda ash

Stirring implement

Tip: *If you rinse off the worst of the waste under a tap, your washing water is cleaner and less likely to stain the white pattern.*

2

2
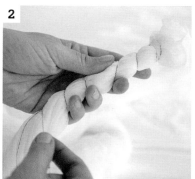

2
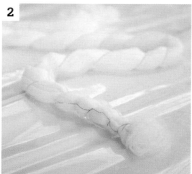

3
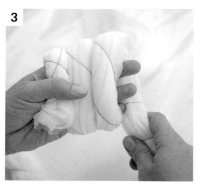

3
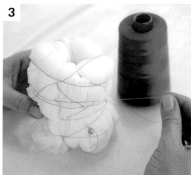

5
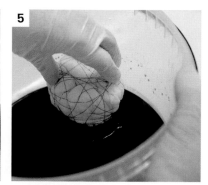

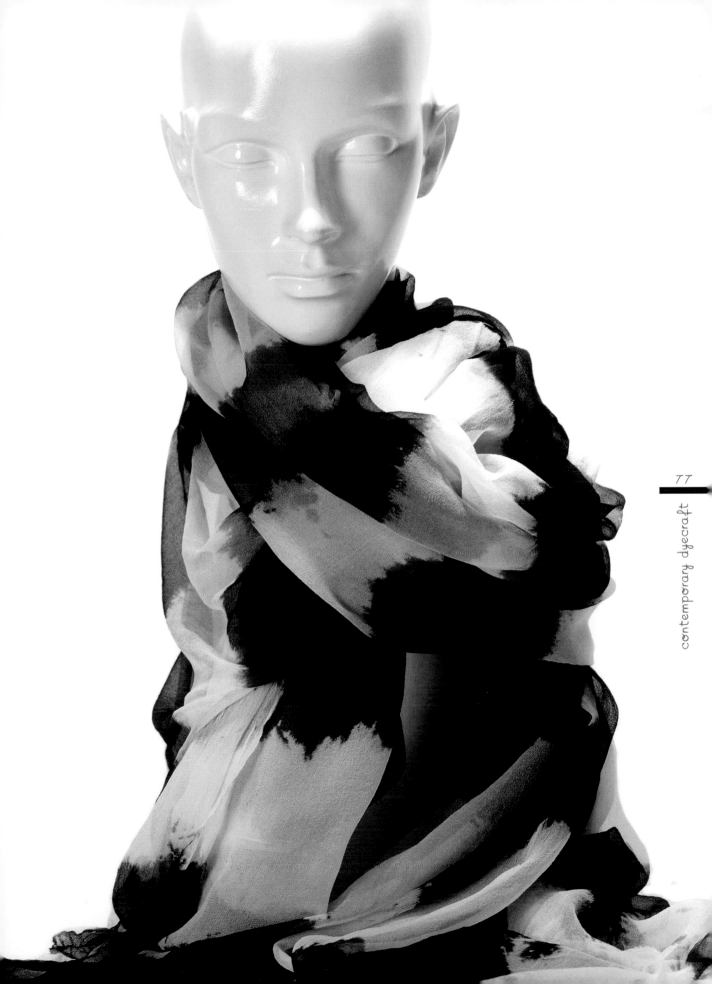

Candy-striped silk

You decide in which direction you want the stripes to run. Try them in any direction on this multi-coloured chiffon-silk scarf.

1. Wash and prepare the fabric in the usual way (see page 23).
2. Grip the fabric along the selvage and create evenly spaced gathers. Smooth the folds evenly lengthways and lay the "sausage" on the table. Gently wrap it up with string down the length. The string should not be tight. It is simply a loose loop created to hold the shape together.
3. Wrap the sausage loosely around your hand to create a coil. Wrap the coils in place with string. Again, it should not be tight enough to constrict the fabric and make a mark. It is there to hold the bound shape in place.
4. Place the coil inside an empty bucket and check how much dye you need to pour in to make the liquid come up to the halfway mark on the coil. Do this before you mix the dye so that you have time to plan clearly. Take out the coil.
5. Boil the kettle and pour 2 quarts (2 L) water into the bucket. Mix the first color. Stir in the dye, the salt and the soda ash and make sure all the lumps are dissolved. Pour the planned quantity of dye into another bucket and place the coil in the liquid. The mixture should reach the halfway level on the coil. Jiggle the container lightly for a minute and place it one side to stand for one hour. Remove the fabric and let it drain for 5 mins.
6. Mix the second color and repeat the process to cover the other half of the coil in the same way. Leave the bucket to stand for an hour.
7. Wash well in warm, soapy water, adding fabric softener to the last rinse.

YOU WILL NEED

2 yards (2 m) white chiffon silk

String

Three 2-quart (2 L) buckets

Kettle

Pink and blue dye

Salt

Soda ash

Stirring implement

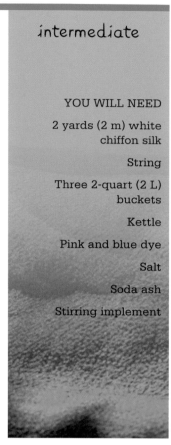

stripes and coils

2

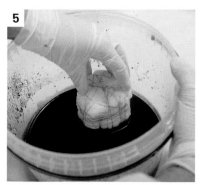

3

3

5

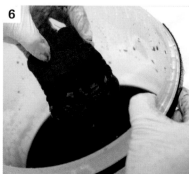

5

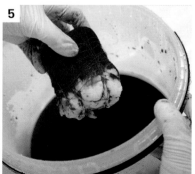

6

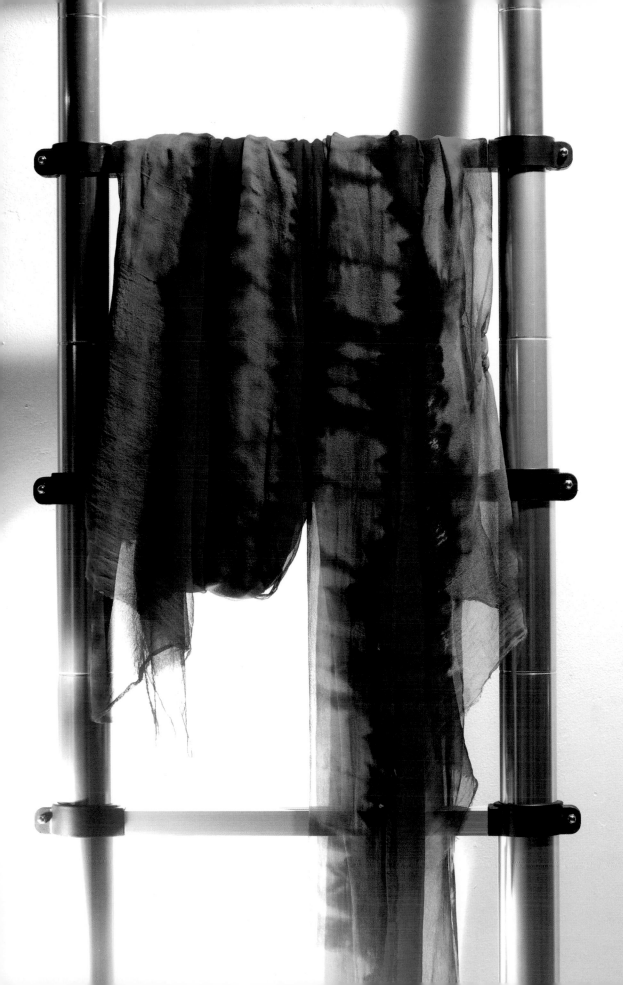

Diagonal-striped silk

Diagonal stripes are flattering – let's make some in one color on a chiffon silk scarf. This finish in turquoise and white is fresh and light for summer.

easy

YOU WILL NEED

2 yards (2 m) white chiffon silk

String

Two 2-quart (2-L) buckets

Kettle

Turquoise dye

Salt

Soda ash

Stirring implement

Tip: *If you rinse the worst of the waste off under a tap, your washing water is cleaner and less likely to stain the white pattern.*

1. Wash and prepare the fabric in the usual way (see page 23).

2. Grip the fabric by one corner and allow the folds to drape downward. Smooth the folds evenly lengthways and lay the "sausage" on the table. Gently wrap it up with string down the length. The string should not be tight. It is simply a loose loop created to hold the shape together.

3. Wrap the sausage loosely around your hand to create a coil. Wrap the coils in place with string. Again, it should not be tight enough to constrict the fabric and make a mark. It is there to hold the bound shape in place.

4. Place the coil inside an empty bucket and check how much dye you need to pour in to make the liquid come up to the halfway mark on the coil. Do this before you mix the dye so that you have time to think and plan clearly. Take out the coil.

5. Boil the kettle and pour 2 quarts (2 L) water into the bucket. Stir in the dye, the salt and the soda ash and make sure all the lumps are dissolved. Pour the planned quantity of dye into the other bucket and place the coil in the liquid. The mixture should reach the halfway level on the coil. Jiggle the container lightly for a minute and place it aside to stand for one hour.

6. Rinse off the first excess under a running tap and then continue rinsing in the usual way (see pages 25–27).

2 **2** **3**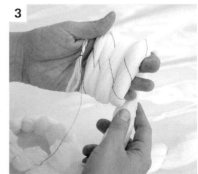

3 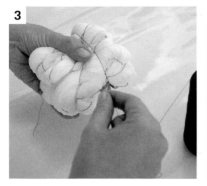 **3** 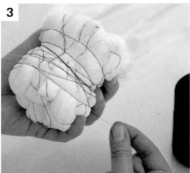 **5**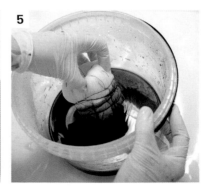

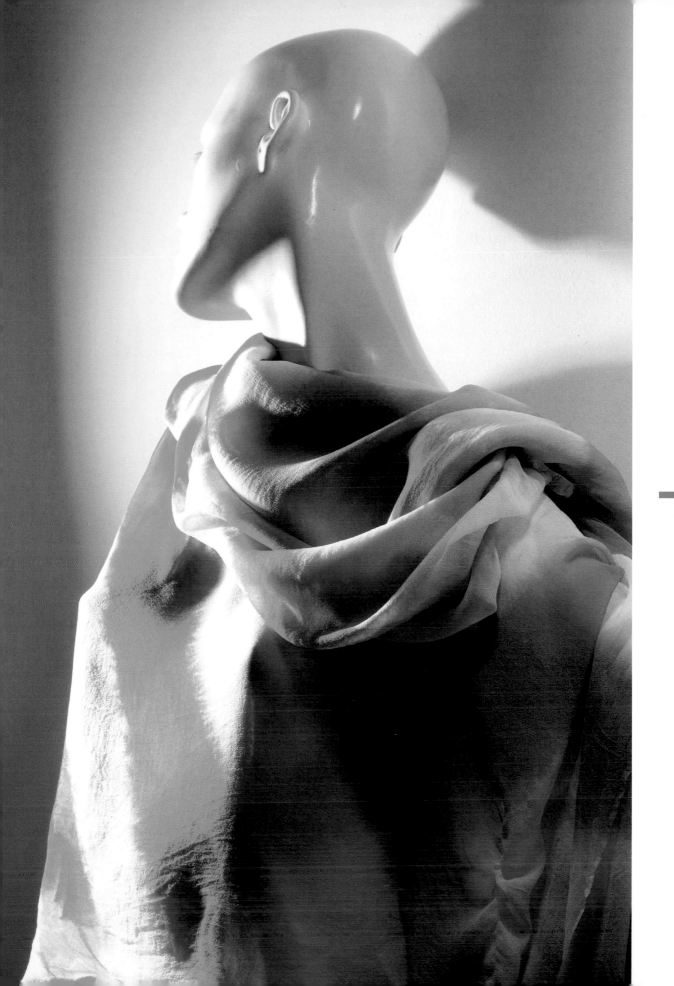

Fire silk

My favourite color by far is the color of fire! Use three warm tones (or three cool tones) for a dramatic effect. This fiery three-color chiffon-silk scarf will warm up any chilly evening.

1. Wash and prepare the fabric (see page 23). Give it a good shake.

2. Grip the fabric by one corner and allow the folds to drape downward. Smooth the folds evenly lengthways and lay the "sausage" on the table. Gently wrap it up with string down the length. The string should not be tight. It is simply a loose loop created to hold the shape together.

3. Wrap the sausage loosely around your hand to create a coil. Wrap the coils in place with string. Again, it should not be tight enough to constrict the fabric and make a mark. It is there to hold the bound shape in place.

4. Place the coil in an empty bucket and check how much dye you must pour in for the liquid to reach the halfway mark on the coil. Take out the coil.

5. Boil the kettle and pour 2 quarts (2 L) water into the bucket. Stir in the gold dye, salt and soda ash and ensure the lumps are dissolved. Pour the planned quantity of dye into another bucket and place the coil in the fluid. The mixture should reach the halfway level on the coil. Jiggle the container lightly for a minute, then let it stand for an hour. Remove the fabric and let it drain for 5 mins.

6. Mix the red dye and repeat the process to cover the other half of the coil in the same way. Leave the bucket to stand for an hour.

7. Mix the brown dye. Pour 3/4 inch (2 cm) of dye into the bucket and place the coil in this shallow bath. Jiggle the bucket for 2 mins and let it stand for an hour.

8. Drain and wash in warm, soapy water. Add fabric softener to the last rinse.

advanced

YOU WILL NEED

2 yards (2 m) white chiffon silk

String

Three 2-quart (2 L) buckets

Kettle

Gold, red and brown dye

Salt

Soda ash

Stirring implement

stripes and coils

2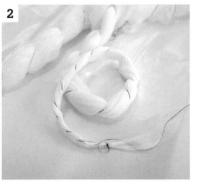

3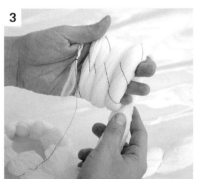

3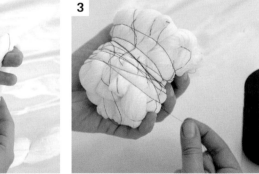

5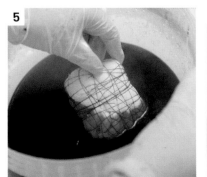

6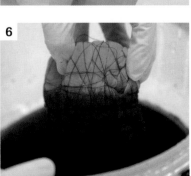

7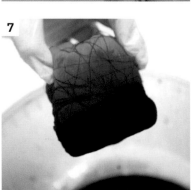

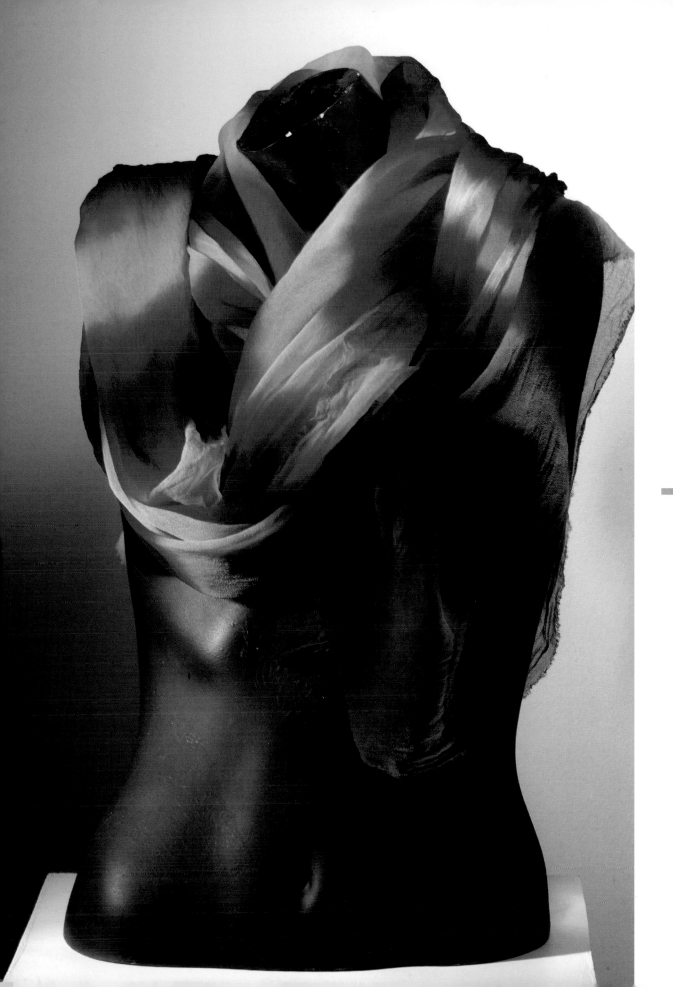

Funky two-stripe shirt

This one is a favorite with boys. People are always drawn to the geometric balance of this shirt.

1. Wash and prepare the shirt in the usual way (see step 2 on page 23). Give it a good shake, lay it on a table and smooth out all the creases. Fold the shirt down the center. Line up the hem and sleeves perfectly. Smooth out any creases between the layers.

2. Working parallel to the hem, create evenly spaced concertina folds. When you get to the sleeves, do not panic, just keep going. Pretend the fabric is just one continuous piece. Once the whole thing has been folded into concertina folds, bind it very tightly with an elastic band in a closed position (looped to form a solid band), approximately halfway along the bundle.

3. Boil the kettle and pour 2 quarts (2 L) water into the bucket. Stir in the dye, the salt and the soda ash and make sure all the lumps are dissolved. Follow the All-in method on page 25.

4. Drop the shirt into the hot dye immediately. Jiggle the container vigorously for 10 mins. Put the filled water bottle on top of the fabric so it does not float above the surface of the dye. Leave it to stand for 24 hours and rinse in the usual way (as described on pages 25–27).

geometric shapes

intermediate

YOU WILL NEED

100% cotton pale blue shirt

Strong elastic bands

Bucket

Kettle

Dark green dye

Salt

Soda ash

Stirring implement

Water bottle filled with water and sealed

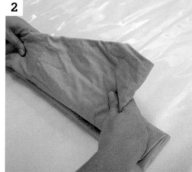

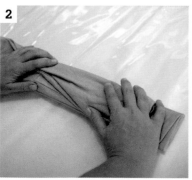

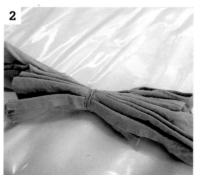

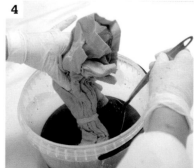

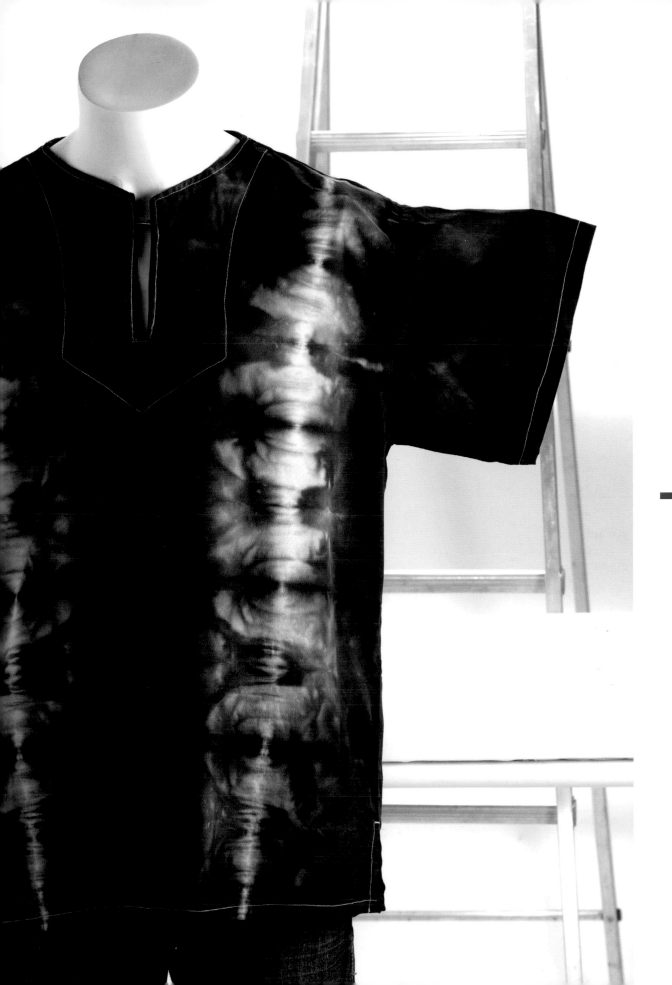

Trax T-shirt

This is the asymmetrical version of the previous technique and is also popular with boys. I started with a red T-shirt and ended up with a dramatic two-color effect.

1. Wash and prepare the T-shirt in the usual way (see page 23). Give it a good shake, lay it on a table and smooth out all the creases. Create a vertical fold, parallel with the side seam, to the one side of the shirt. I like to place it halfway between the neckline and the edge of the sleeve. Smooth out any creases between the layers.

2. Working parallel to the hem, create evenly spaced concertina folds. When you get to the sleeves, do not panic, just keep going. Pretend the fabric is just one continuous piece. Once the whole thing has been folded into concertina folds, bind very tightly with an elastic band in a closed position (looped to form a solid band), approximately 1/2 inch (1 cm) away from the folded edge. Bind a second elastic band tightly in a closed position 1/2 inch (1 cm) down from that.

3. Boil the kettle and pour 2 quarts (2 L) water into the bucket. Stir in the dye, the salt and the soda ash and make sure all the lumps are dissolved. Follow the All-in method on page 25.

4. Drop the T-shirt into the hot dye immediately. Jiggle the container vigorously for 10 mins. Put the filled water bottle on top of the fabric so it does not float above the surface of the dye. Leave it to stand for 24 hours and rinse in the usual way (as outlined on pages 25–27).

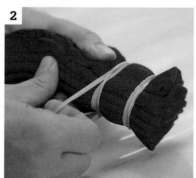

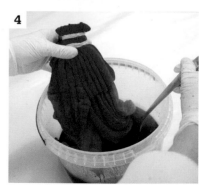

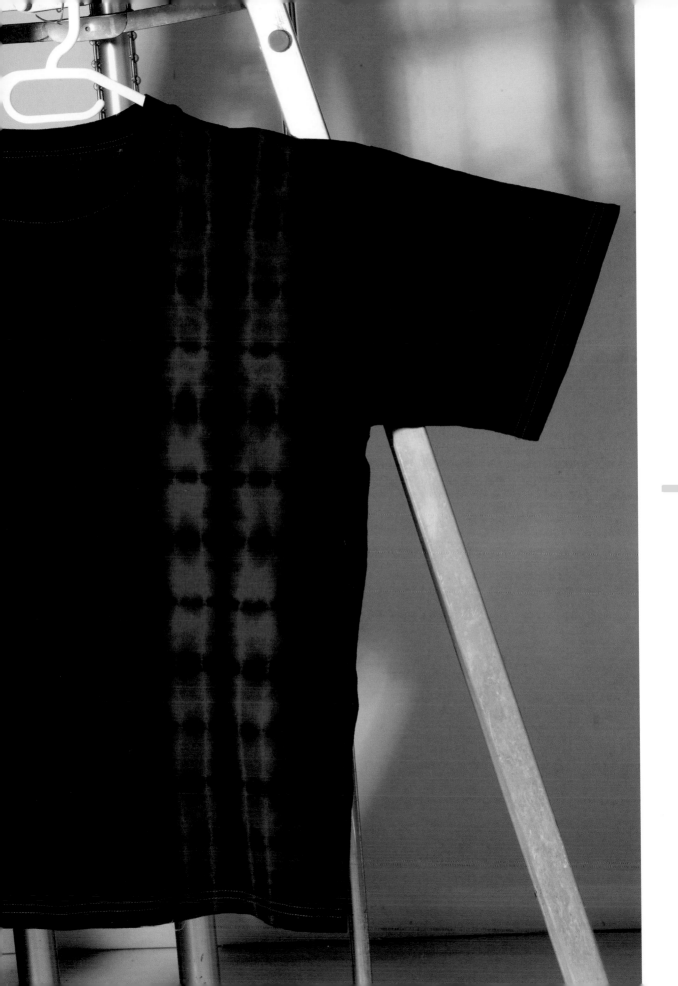

Parallel-striped shirt

Vertical stripes are always slimming. This is an easy technique in a one-color finish.

1. Wash and prepare the shirt in the usual way (see page 23). Give it a good shake, lay it on a table and smooth out all the creases. Fold it down the center. Line up the hem and sleeves perfectly. Smooth out any creases between layers.

Tip: *If you fold the shirt in half first, the garment will have a more balanced look.*

2. Working parallel to that, create evenly spaced concertina folds about 1–1½ inches (3–4 cm) wide. When you get to the sleeves, do not panic, just keep going. Pretend the fabric is just one continuous piece. Once the whole thing has been folded into concertina folds, bind it securely with string by winding it around the bundle, all down the length. The bundle needs to be quite firm. If it is very loose and there is no pressure between the folds of fabric, your pattern will disappear. Tie the string off so it does not come loose in the dye.

3. Boil the kettle and pour 2 quarts (2 L) water into the bucket. Stir in the dye, salt and soda ash and make sure all the lumps are dissolved (follow the All-in method on page 25).

4. Drop the shirt into the hot dye immediately. Jiggle the container vigorously for 10 mins. Put the filled water bottle on top of the fabric so it does not float above the surface of the dye. Leave it to stand for 24 hours and rinse in the usual way (see pages 25–27).

easy

YOU WILL NEED

100% cotton pale blue shirt

String

Bucket

Kettle

Navy blue dye

Salt

Soda ash

Stirring implement

Water bottle filled with water and sealed

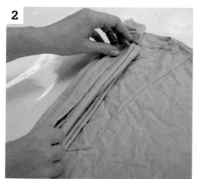

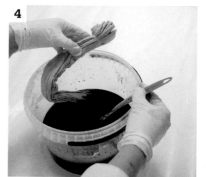

geometric shapes

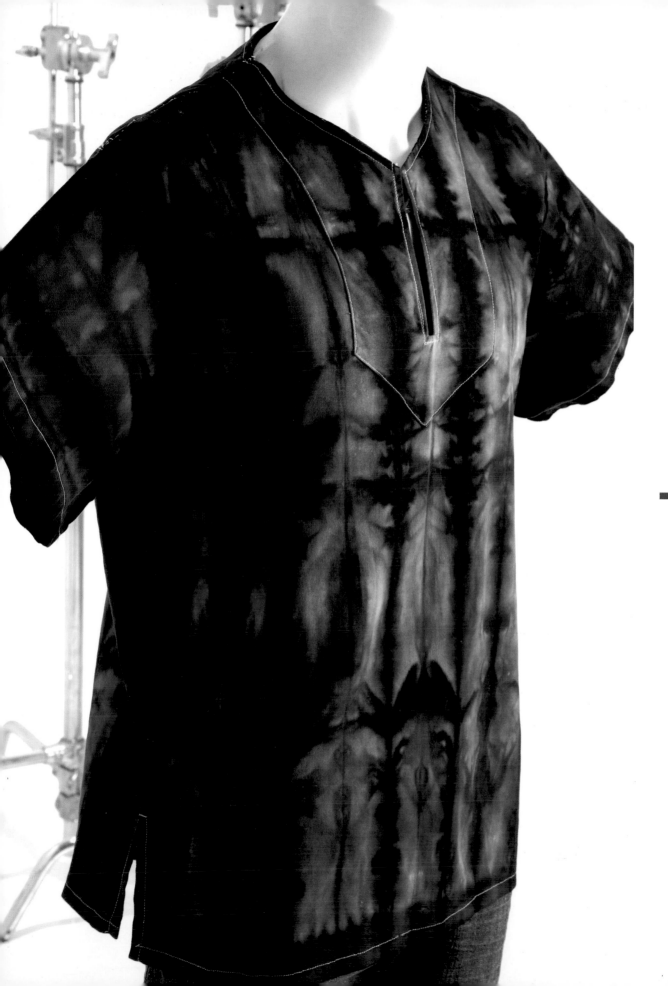

Offset horizontal-striped T-shirt

I once made myself a shirt like this. Every time I wore it, somebody stopped me and asked where I got it. This technique also goes over well with boys.

1. Wash and prepare the T-shirt in the usual way (see page 23). Give it a good shake, lay it on a table with the front side up and smooth out all the creases. Fold the T-shirt down the center. Line up the hem and sleeves perfectly. Smooth out any creases between the layers.

2. Working parallel to the hem, create evenly spaced concertina folds approximately 1 to 1½ inches (3–4 cm) wide. When you get to the sleeves, do not panic, just keep going. Pretend the fabric is just one continuous piece. Once the whole thing has been folded into concertina folds, bind it securely with string by winding it around the bundle, all down the length. The bundle needs to be quite firm. Tie the string off so it does not work loose in the process.

3. Put on your face mask, gloves and goggles. Pour straight bleach into the bottom of the bucket approximately 2 inches (5 cm) deep.

4. Place the T-shirt in the bucket and jiggle it around for 30 seconds. Take it out, turn it over, and put it back in to expose the other side to the bleach. Watch the colour start to change. When the colour has lightened visibly, plunge the fabric straight into clean cold water and rinse. Keep on rinsing in clean water with a bit of soap until you have completely washed out the smell.

5. Add a little bit of fabric softener to the final rinse. Dry on a coat hanger indoors.

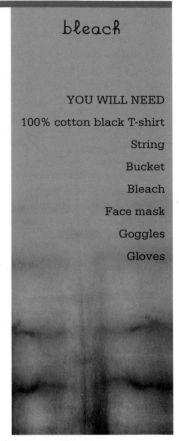

bleach

YOU WILL NEED

100% cotton black T-shirt

String

Bucket

Bleach

Face mask

Goggles

Gloves

geometric shapes

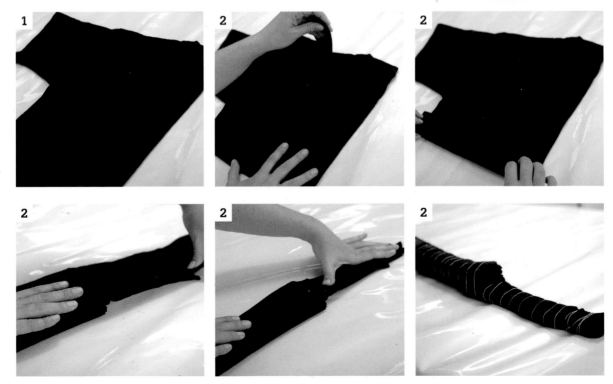

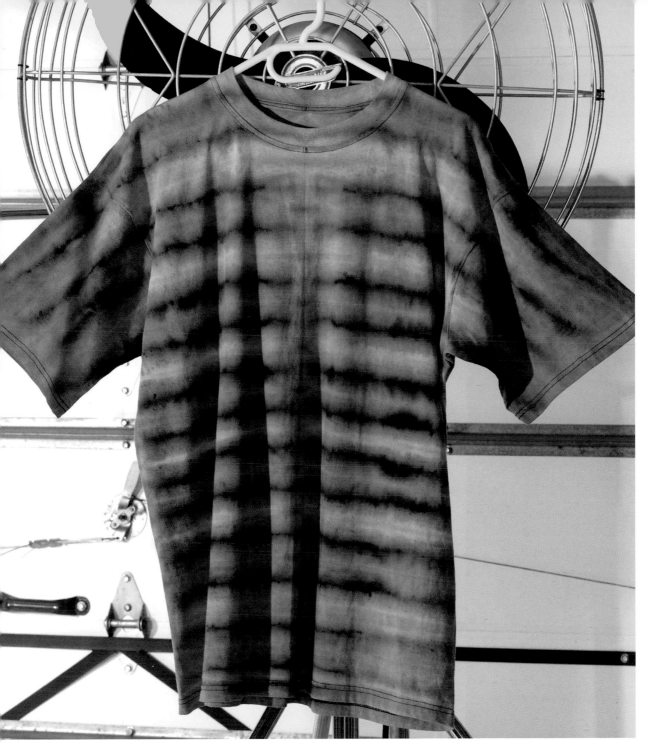

4

4

4

Parallel fan-striped skirt

Vertical stripes on a flared skirt are slimming and fun.

1. Wash and prepare the skirt in the usual way (see page 23). Give it a good shake, lay it on a table and smooth out all the creases. Fold it down the center. Line up the hem and side seams perfectly. Smooth out any creases between the layers.

2. Using the center fold as a guide, create evenly spaced concertina folds approximately 1 to 1½ inches (3–4 cm) wide. Your folds are going to have to angle slightly inward toward the top of the skirt so that they run in line with the side seams.

3. Once the whole thing has been folded into concertina folds, bind it securely with string by winding it around the bundle, all down the length. The bundle needs to be quite firm. If it is very loose and there is no pressure between the folds of fabric, your pattern will disappear. Tie the string off so it does not come loose in the dye.

4. Boil the kettle and pour 2 quarts (2 L) water into the bucket. Stir in the dye, the salt and the soda ash and make sure all the lumps are dissolved.

5. Drop the skirt into the hot dye immediately. Jiggle the container vigorously for 10 mins. Put the filled water bottle on top of the fabric so it does not float above the surface of the dye. Leave it to stand for 24 hours and rinse in the usual way (as outlined on pages 25–27).

YOU WILL NEED

100 % cotton khaki skirt

String

Bucket

Kettle

Brown dye

Salt

Soda ash

Stirring implement

Water bottle filled with water and sealed

geometric shapes

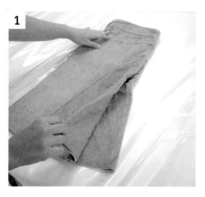

1

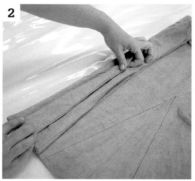

2

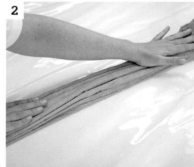

2

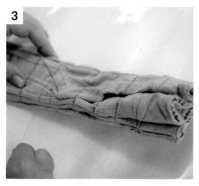

3

3

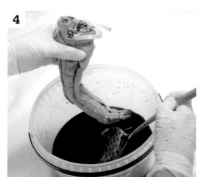

4

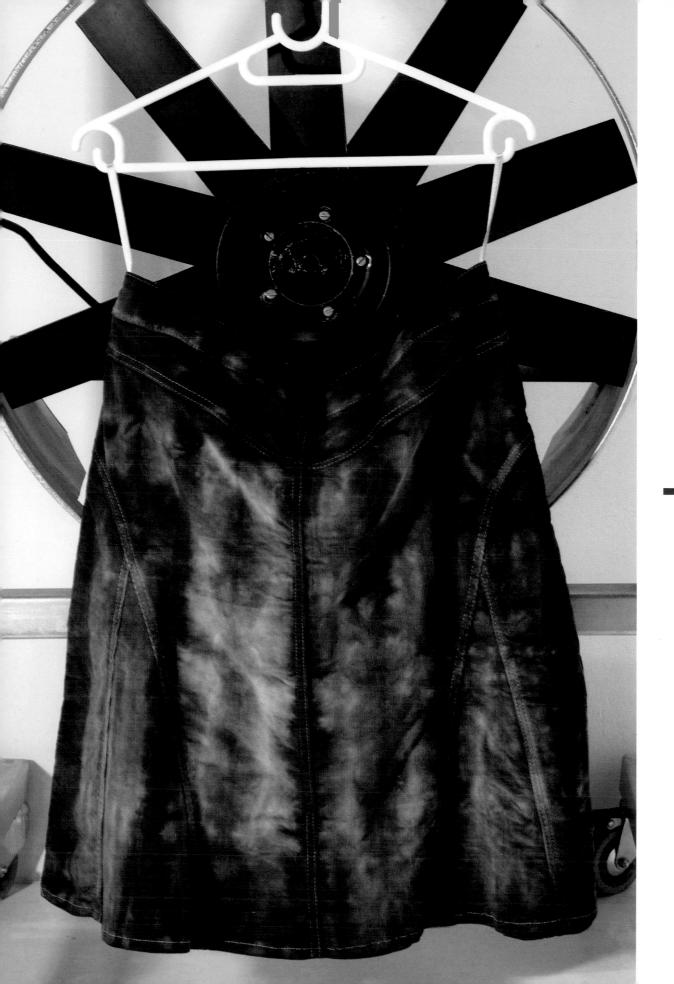

Zigzag silk

Angle your stripes to create zigzags for an eye-catching, dynamic chiffon-silk scarf.

1. Wash and prepare the fabric (see step 2 on page 23). Give it a good shake.

2. Hold the fabric along the selvage. Fold it in half. Fold it in half two more times. This will leave you with a flat bundle of fabric about 10 inches (25 cm) wide. Lay it flat on a table and smooth out the worst of the creases.

Tip: *Chiffon silk is very difficult to control. Do the best you can.*

3. Create a fold at a 45° angle. Using that as a guide, create evenly spaced concertina folds parallel to that. Use the string to hold the folds in place by wrapping it around the bundle. The string acts simply as a stabilizer so the folds do not distort when you add the elastic bands.

4. Bind elastics very tightly in a closed position (looped to form a solid band) at 4-inch (10 cm) intervals along the bundle. Because a chiffon silk has such an open weave, you must completely constrict the fabric with elastic bands to create the pattern. If your bindings are loose, the pattern can disappear altogether.

5. Boil the kettle and pour 2 quarts (2 L) water into the bucket. Stir in the dye, the salt and the soda ash and make sure all the lumps are dissolved. Follow the All-in method (page 25). Place the scarf in the hot dye and leave it to stand for an hour before washing thoroughly in warm, soapy water until the rinse water runs clear. Add a little fabric softener in the last rinse.

YOU WILL NEED

2 yards (2 m) white chiffon silk

String and elastic bands

Bucket

Kettle

Red dye

Salt

Soda ash

Stirring implement

94

geometric shapes

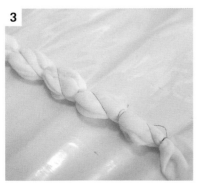
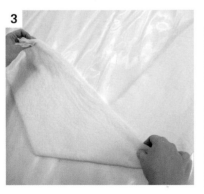

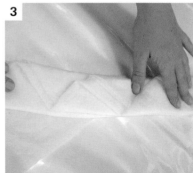
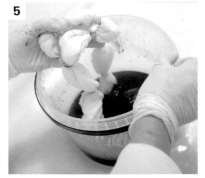

V-Pattern shirt

Start with a plain V-neck shirt and add a striking one-color finish.

1. Wash and prepare the T-shirt (see page 23). Give it a good shake, lay it on a table and smooth out all the creases. Create a vertical fold, parallel with the side seam, down the center of the shirt. Smooth out any creases between the layers.
2. Create a fold at a 45° angle to the first fold. Working parallel to that, create evenly spaced concertina folds. When you get to the sleeves, do not panic, just keep going. Pretend the fabric is one continuous piece. Once the whole thing has been folded into concertina folds approximately 1½ inches (4 cm) wide, wrap them in place using string.
3. Scan down the length of the bundle and figure out where the neckline starts. Bind an elastic band very tightly in a closed position (looped to form a solid band) just on the edge of the rib trim on the neck. Place another tight elastic band approximately 4 inches (10 cm) farther down the bundle.
4. Boil the kettle and pour 2 quarts (2 L) water into the bucket. Stir in the dye, the salt and the soda ash and make sure all the lumps are dissolved. Follow the All-in method on page 25.
5. Drop the shirt into the hot dye immediately. Jiggle the container vigorously for 10 mins. Put the filled water bottle on top of the fabric so it does not float above the surface of the dye. Leave it to stand for 24 hours and rinse in the usual way (see pages 25–27).

YOU WILL NEED

100% cotton light blue V-neck shirt

String and strong elastic bands

Bucket

Kettle

Purple dye

Salt

Soda ash

Stirring implement

Water bottle filled with water and sealed

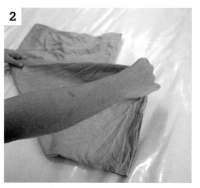

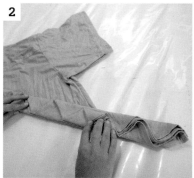

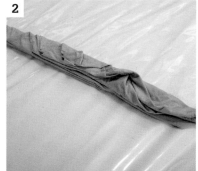

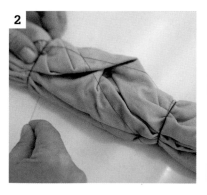

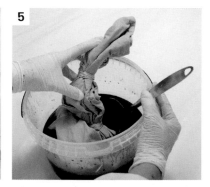

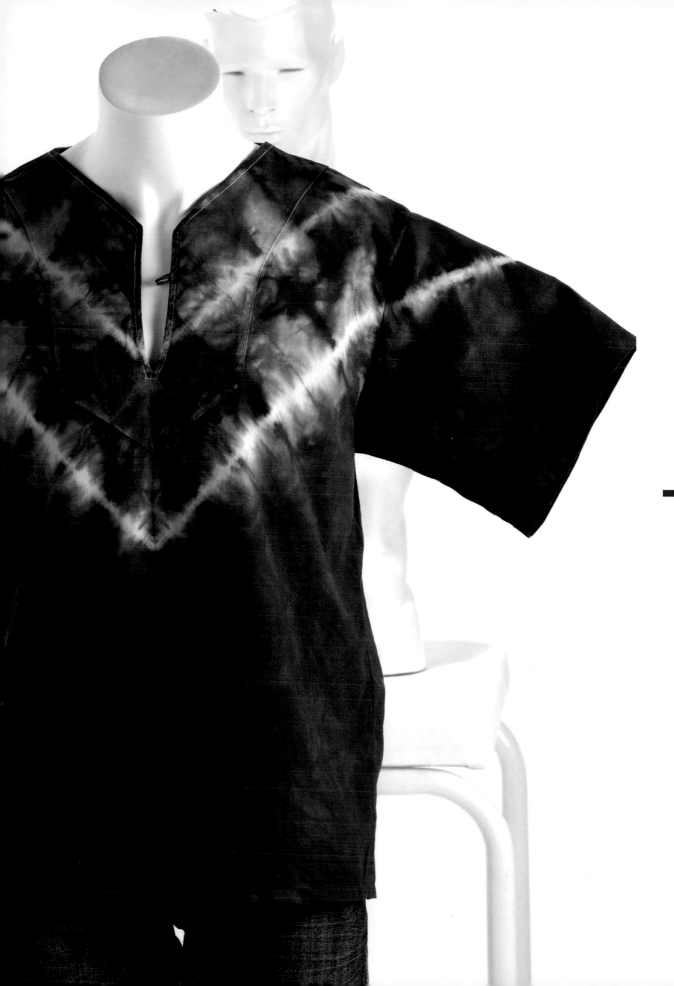

Snakeskin T-shirt

This technique always reminds me of snakeskin. To make it really snaky, begin with a beige or brown T-shirt and add a black finish.

1. Wash and prepare the T-shirt in the usual way (see page 23). Give it a good shake, lay it on a table and smooth out all the creases. Create a vertical fold, parallel with the side seam, down the center of the shirt. Smooth out any creases between the layers.

2. Create a fold at a 45° angle to the first fold. Working parallel to that, create evenly spaced concertina folds. When you get to the sleeves, do not panic, just keep going. Pretend the fabric is one continuous piece. Fold the whole thing up with concertina folds approximately 1½ inches (4 cm) wide.

3. Use the string to bind the folds in place. Work in an orderly way. Wrap the string repeatedly in certain places to create extra pressure at evenly spaced intervals. The tighter you make the string and the closer together the spacing, the more the base color will shine through the black.

4. Boil the kettle and pour 2 quarts (2 L) water into the bucket. Stir in the dye, the salt and the soda ash and make sure all the lumps are dissolved. Follow the All-in method on page 25.

5. Drop the T-shirt into the hot dye immediately. Jiggle the container vigorously for 10 mins. Put the filled water bottle on top of the fabric so it does not float above the surface of the dye. Leave it to stand for 24 hours and rinse in the usual way (see pages 25–27).

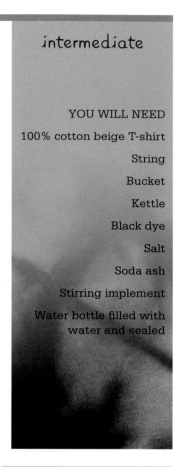

intermediate

YOU WILL NEED

100% cotton beige T-shirt

String

Bucket

Kettle

Black dye

Salt

Soda ash

Stirring implement

Water bottle filled with water and sealed

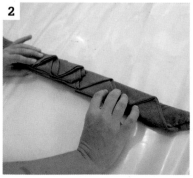

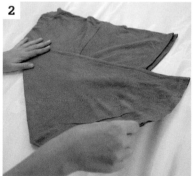

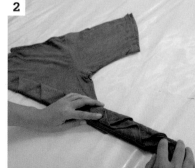

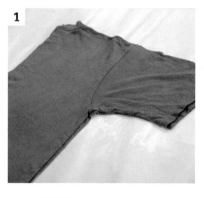

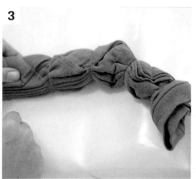

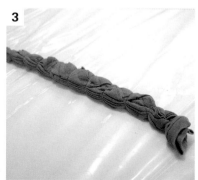

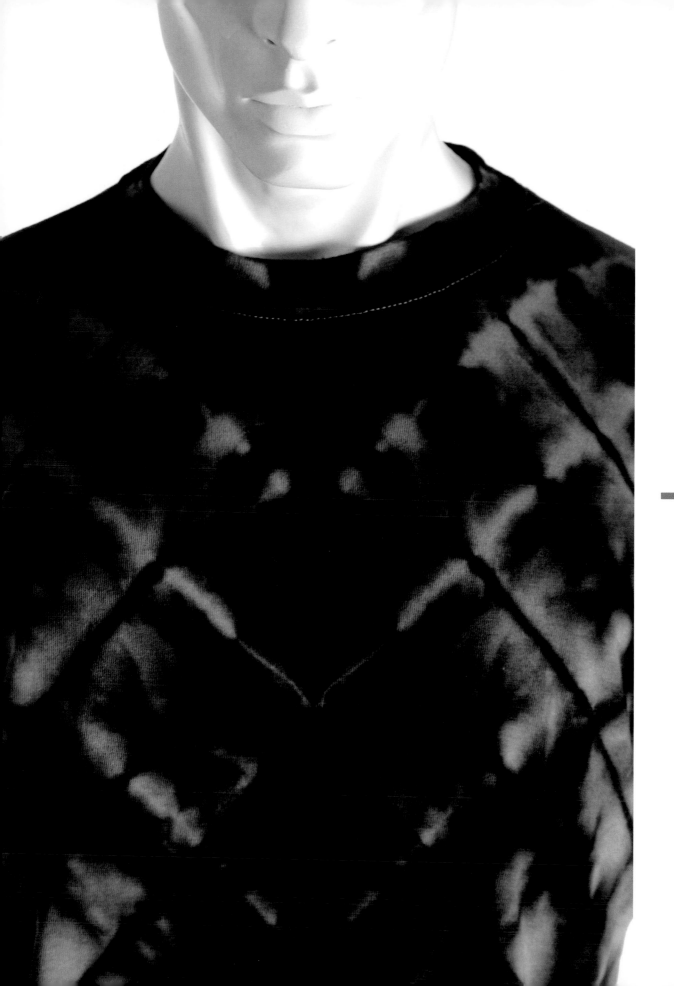

Diamond T-shirt

This black-and-white diamond pattern is simply eye-catching. I have used this technique on everything, from clothing to home decor items.

1. Wash and prepare the T-shirt in the usual way (see page 23). Give it a good shake, lay it on a table and smooth out all the creases. Create a vertical fold, parallel with the side seam, down the center of the shirt. Smooth out any creases between the layers. Working parallel to the hem, fold the shirt in half again.

2. Create a fold at a 45° angle to the first fold. Working parallel to that, create evenly spaced concertina folds. When you get to the sleeves, do not panic, just keep going. Pretend the fabric is just one continuous piece. Once the whole thing has been folded into concertina folds approximately 1½ inches (4 cm) wide, wrap them in place using string.

3. Bind very tight elastic bands in closed positions (looped to form solid bands) at 2¾-inch (7 cm) intervals all along the length of the bundle.

4. Boil the kettle and pour 2 quarts (2 L) water into the bucket. Stir in the dye, the salt and the soda ash and make sure all the lumps are dissolved. Follow the All-in method on page 25.

5. Drop the T-shirt into the hot dye immediately. Jiggle the container vigorously for 10 mins. Put the filled water bottle on top of the fabric so it does not float above the surface of the dye. Leave it to stand for 24 hours and rinse in the usual way (see pages 25–27).

YOU WILL NEED

100% cotton white T-shirt

String and strong elastic bands

Bucket

Kettle

Black dye

Salt

Soda ash

Stirring implement

Water bottle filled with water and sealed

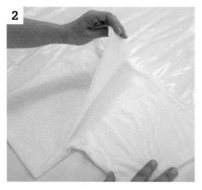

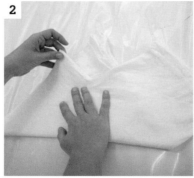

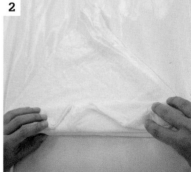

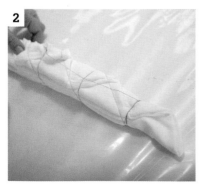

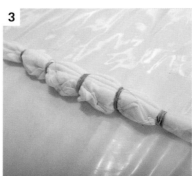

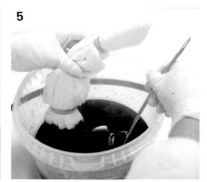

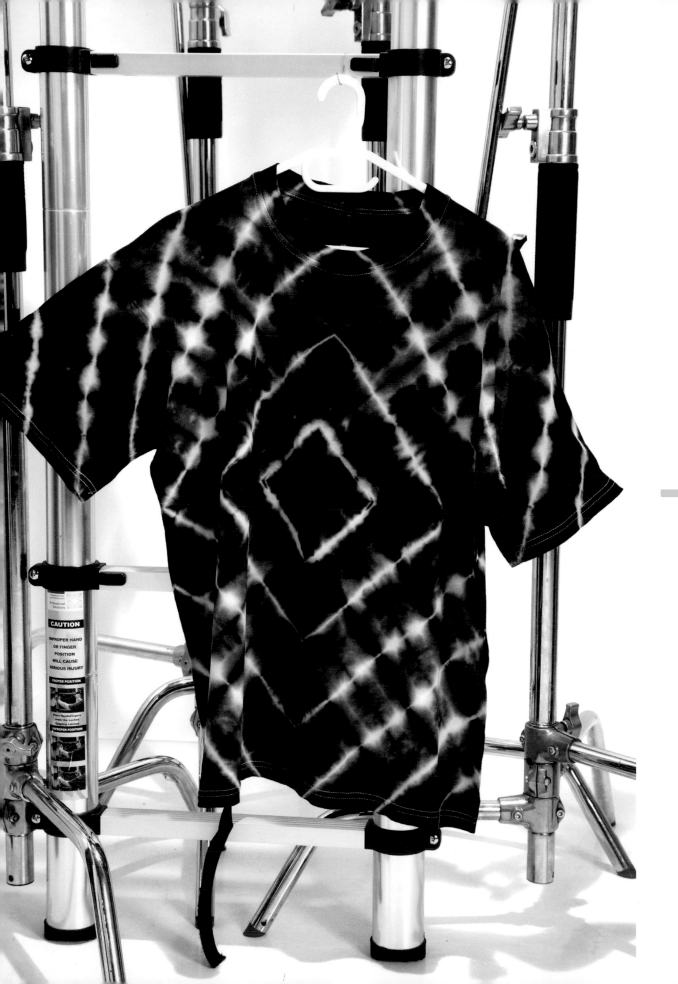

Reverse diamond T-shirt

Create wild geometric shapes with bleach on a black T-shirt.

1. Wash and prepare the T-shirt (see page 23). Give it a good shake, lay it on a table with the front side up and smooth out the creases. Fold the T-shirt down the center. Line up the hem and sleeves perfectly. Smooth out any creases.
2. Working parallel to the hem, fold the shirt in half again. Create a diagonal fold from the center of the shirt at a 45° andgle. Smooth out all the creases between the layers as you work. Parallel to this fold, create evenly spaced concertina folds approximately 1½ inches (4 cm) wide. When you get to the sleeves, do not panic, just keep going. Pretend it is one continuous piece of fabric. Once it has been folded into concertina folds, wind string around the bundle, all down the length to hold the folds securely in place so that they don't distort when you tighten the elastic bands. Bind the bundle tightly with elastic bands at regular intervals, about 2⅔ inches (6 cm) apart.
3. Put on your face mask and goggles. Pour straight bleach into the bottom of the bucket, approximately 2 inches (5 cm) deep.
4. Place the T-shirt in the bucket and jiggle it around for 30 seconds. Take it out, turn it over, and put it back in to expose the other side to the bleach. Watch the color start to change. When the color has lightened visibly, plunge the fabric straight into clean cold water and rinse. Keep on rinsing in clean water with a bit of soap until you have washed out the smell completely.
5. Add fabric softener to the final rinse. Dry on a coat hanger indoors.

YOU WILL NEED

100% cotton black T-shirt

String and strong elastic bands

Bucket

Bleach

Face mask

Goggles

Gloves

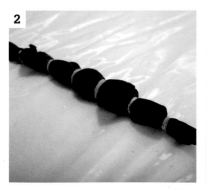

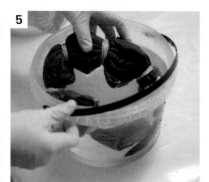

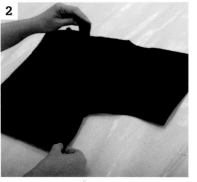

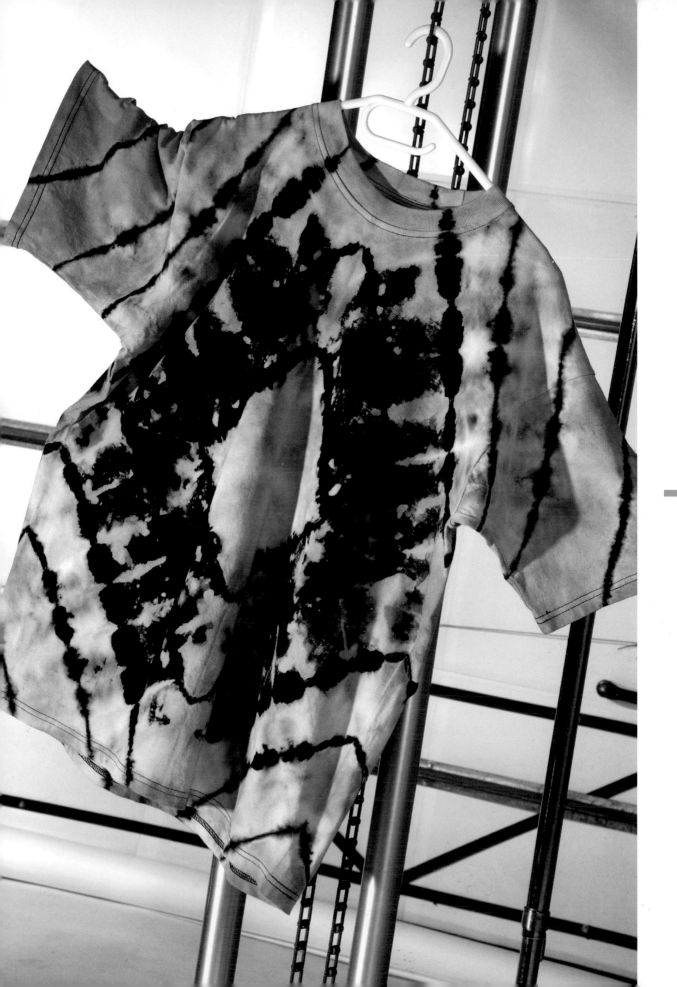

Cross T-shirt

Start with a white T-shirt and add a one-color finish. This geometric pattern is popular with boys.

1. Wash and prepare the T-shirt in the usual way (see page 23). Give it a good shake, lay it on a table and smooth out all the creases. Create a vertical fold, parallel with the side seam, down the center of the shirt. Smooth out any creases between the layers.

2. Working parallel to the hem, fold the shirt in half again. Create a fold at a 45° angle from the side seam. Smooth out all the creases between the layers. Working parallel to that, create evenly spaced concertina folds approximately 2 inches (5 cm) wide. When you get to the sleeves, do not panic, just keep going. Pretend it is one continuous piece. Fold the whole thing up with concertina folds. Use the string to bind the folds in place.

3. The bundle will have a little triangular flap on top, created in the middle of the shirt by the first two folds. Bind a 2-inch (5 cm) strip of elastic bands solidly across this flap, tight enough to completely constrict the fabric. The bands must be so close together that no fabric is visible beneath them.

4. Boil the kettle and pour 2 quarts (2 L) water into the bucket. Stir in the dye, the salt and the soda ash and make sure all the lumps are dissolved. Follow the All-in method on page 25.

5. Drop the T-shirt into the hot dye immediately. Jiggle the container vigorously for 10 mins. Put the filled water bottle on top of the fabric so it does not float above the surface of the dye. Leave it to stand for 24 hours and rinse in the usual way (see pages 25–27).

advanced

YOU WILL NEED

100% cotton white T-shirt

String and strong elastic bands

Bucket

Kettle

Purple dye

Salt

Soda ash

Stirring implement

Water bottle filled with water and sealed

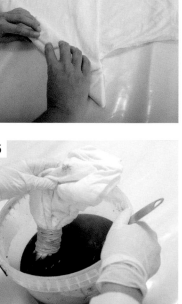

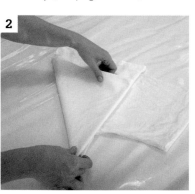

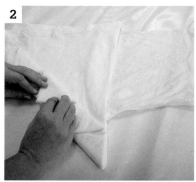

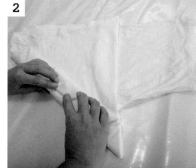

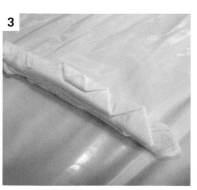

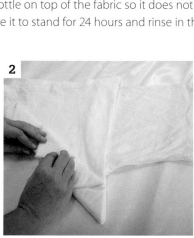

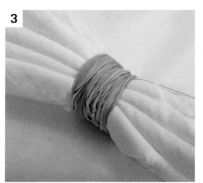

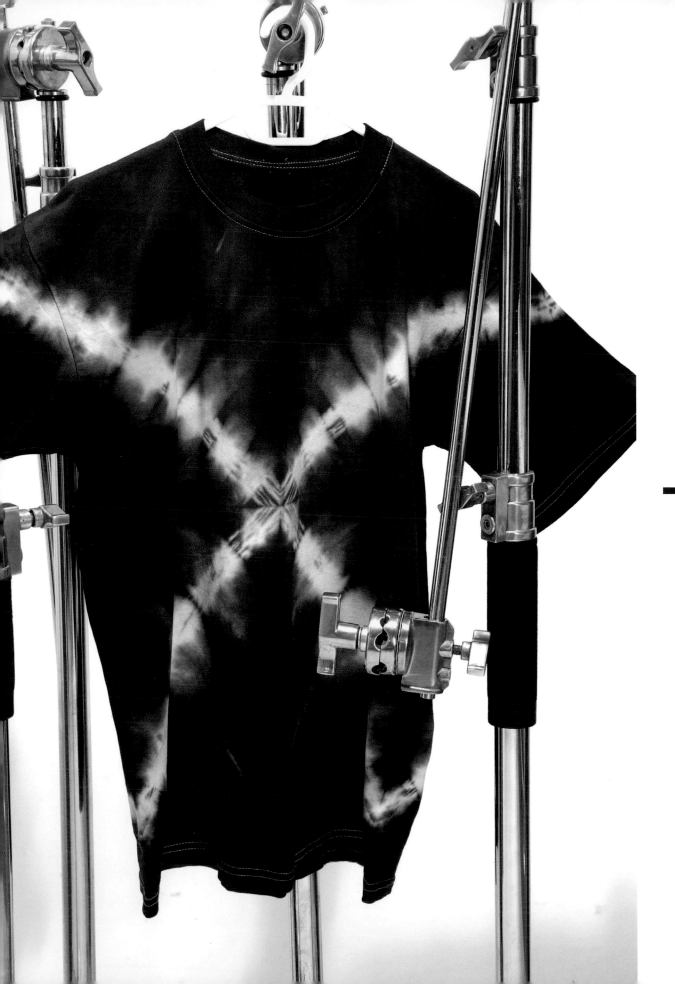

Check silk

Checks are always sexy and chic. Create this striking chiffon-silk scarf in lime green and white to go with your evening wear.

1. Wash and prepare the fabric in the usual way (see step 2 on page 23). Give it a good shake.

2. Hold the fabric along the selvage. Fold it in half. Smooth out the creases between the layers. Create evenly spaced concertina folds, parallel to this fold, approximately 2¾ inches (7 cm) apart. Once you have created folds across all of the fabric, turn it 90° and do the same in the other direction. Apply elastic bands very tightly across the center of the block that you have created, running in both directions to create a cross.

Tip: *Chiffon silk is very difficult to control. While I recommend that you smooth out as many creases as possible, the fabric often does not play along. Do the best you can and do not overthink it.*

3. Boil the kettle and pour 2 quarts (2 L) water into the bucket. Stir in the dye, the salt and the soda ash and make sure all the lumps are dissolved. Follow the All-in method on page 25.

4. Place the scarf in the hot dye and leave it to stand for an hour before washing thoroughly in warm, soapy water. Add a little fabric softener in the last rinse (see pages 25–27 for details on rinsing).

YOU WILL NEED

2 yards (2m) white chiffon silk

Strong elastic bands

Bucket

Kettle

Lime green dye

Salt

Soda ash

Stirring implement

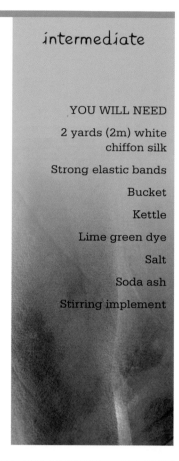

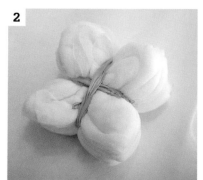
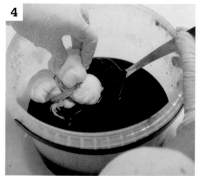

Rainbow silk

This finish in five colors on chiffon silk is sure to brighten your day — and your wardrobe! The diamond motif is prevalent in African artwork, beading and design.

1. Wash and prepare the fabric in the usual way (see page 23). Give it a good shake.

2. Hold the fabric along the selvage. Fold it in half. Smooth out the creases between the layers. Fold it in half again in the other direction. Create another fold at a 45° angle from the center point. Create evenly spaced concertina folds, parallel to this fold, approximately 2 inches (5 cm) wide. Wrap the folds in place using string. "Nip" the fabric at evenly-spaced intervals by winding the string around the same place three times. There should be four of these nips at regular intervals and five sections of fabric once you have finished. Apply very tight elastic bands at these points to completely constrict the fabric (see diagram below).

3. Boil the kettle and pour 2 quarts (2 L) water into a bucket. Stir in the gold dye, the salt and the soda ash and make sure all the lumps are dissolved.

advanced

YOU WILL NEED

2 yards (2 m) white chiffon silk

String and strong elastic bands

2 two-quart (2-L) buckets

Kettle

Gold, red, royal blue and black dye (blue and gold will be mixed on the fabric to make green)

Salt

Soda ash

Stirring implement

Crocodile clip

Place the elastic bands as indicated in the diagram.

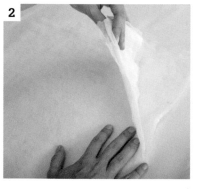
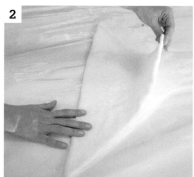
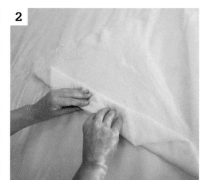

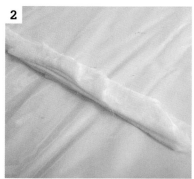
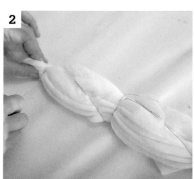
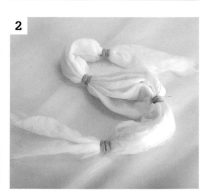

108

geometric shapes

4. Hang the fabric from above, using the crocodile clip, with four of the five segments in the hot gold dye. Leave it to stand for 30 mins. Remove it and let it drain for 5 mins.

5. Boil the kettle and pour 2 quarts (2 L) water into a bucket. Stir in the red dye, the salt and the soda ash and make sure all the lumps are dissolved.

6. Hang the fabric from above, using the crocodile clip, with two of the five segments in the hot red dye. Leave it to stand for 30 mins. Remove it and let it drain for 5 mins.

7. Boil the kettle and pour 2 quarts (2 L) water into a bucket. Stir in the black dye, the salt and the soda ash and make sure all the lumps are dissolved.

8. Hang the fabric from above, using the crocodile clip, with one of the five segments in the hot black dye, overlapping the red. Leave it to stand for 30 mins. Remove it and let it drain for 5 mins.

9. Boil the kettle and pour 2 quarts (2 L) water into a bucket. Stir in the blue dye, the salt and the soda ash and make sure all the lumps are dissolved.

10. Turn the fabric the other way around. Hang it from above, using the crocodile clip, with two of the five segments in the hot blue dye, overlapping one segment of gold. Leave it to stand for 30 mins. Remove it and let it drain for 5 mins.

11. Rinse the fabric under a cold running tap to rinse away the excess. Wash thoroughly in warm soapy water until it runs clear. Add a little fabric softener in the last rinse.

geometric shapes

Follow this diagram for color placement.

4

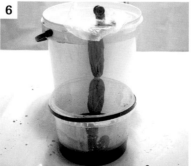

6

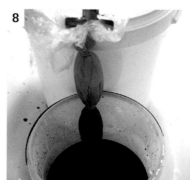

8

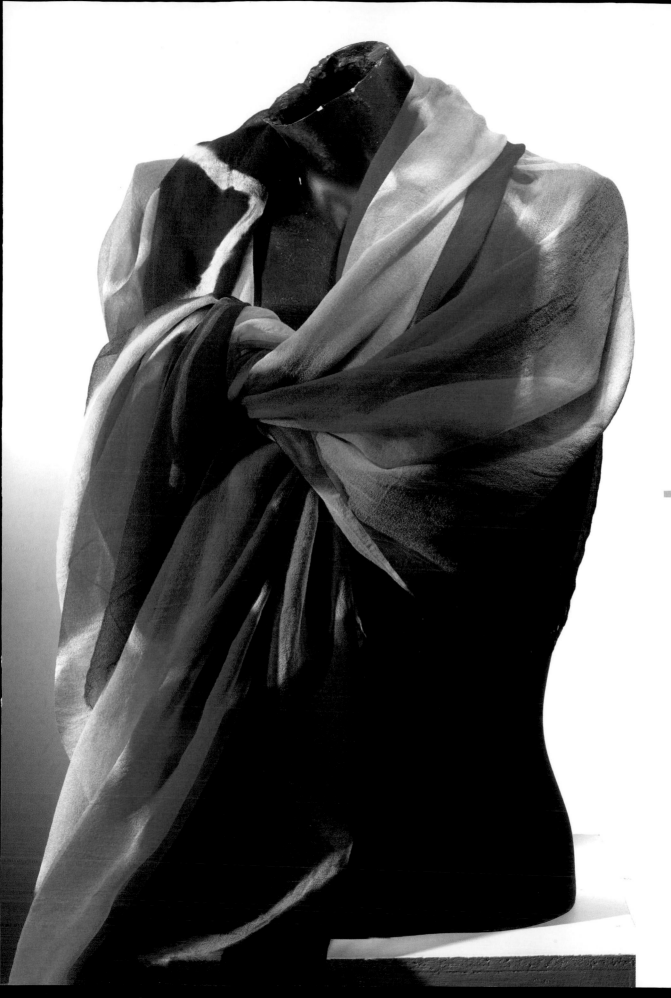

Shell T-shirt

Create a delicate one-color spiral on a white T-shirt. It looks just like a sea shell.

1. Wash and prepare the T-shirt in the usual way (see page 23). Give it a good shake, lay it on a table and smooth out all the creases. Somewhere in the bottom left hand corner, create a crease about 2/3 inch (1.5 cm) deep with the fabric. You must grab both the front and back layers. Lace the crease through the teeth of the fork. Holding it in an upright position, twist the fork in a clockwise direction. More folds will rise up, spiralling out from the fork. Smooth these folds with your free hand around the center twist, until you have a Chelsea bun-like shape.

2. When you get to the sleeves, do not panic, just keep going. Pretend the fabric is one continuous piece. Once the whole thing is a neat bundle, secure the folds in place with three elastic bands. The elastic bands should be evenly spaced to create similar slices and must cross over the center of the twist that you created. They should be tight enough to hold the folds securely in place, but not so tight that they cause the whole bundle to crinkle up.

3. Experiment with the empty bucket first. Place the bundle in the bucket on its side and gauge how much liquid you will need to get the dye exactly up to the center line so that it runs across the center of the twist (you will only be dyeing half of the shirt, so that some of the fabric stays white, as shown in the picture on the facing page). Remember the fabric will displace the fluid a little. Make allowance for this.

4. Boil the kettle and pour 2 quarts (2 L) water into the bucket. Stir in the dye, the salt and the soda ash and make sure all the lumps are dissolved. Pour the required amount of dye into the bottom of the second bucket.

5. Place the bundle in the dye on its side with the fluid up to the center line and jiggle it gently back and forth for 5 mins. Use the crocodile clip to secure the bundle to the side of the bucket so that it does not fall over into the dye.

6. Leave it to stand overnight. Rinse it the following day under a running tap to remove the excess. Keep the white half of the shirt at the top so it is not spoiled by the waste run-off.

7. Wash this T-shirt in cold water with lots of soap until the water runs completely clear. Add fabric softener to the last rinse. Dry flat indoors.

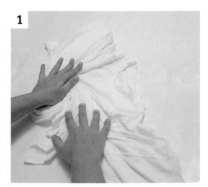

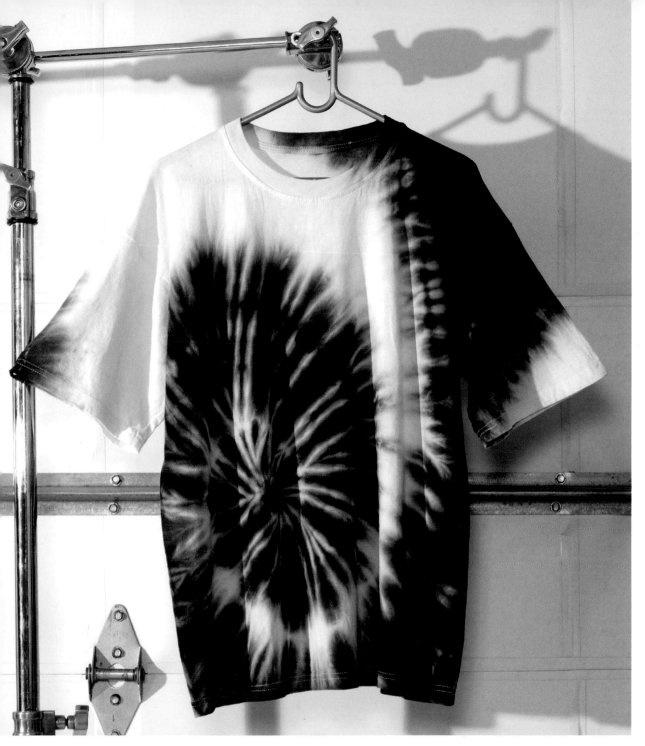

contemporary dyecraft

2

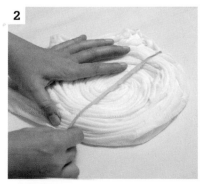

2

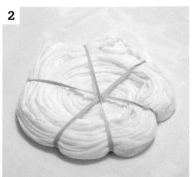

5

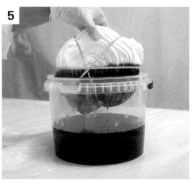

Jungle spikes T-shirt

This technique always reminds me of the jungle when I see it in a dark green on white T-shirt.

YOU WILL NEED

100% cotton white T-shirt

Strong elastic bands

Fork

Bucket

Kettle

Dark green dye

Salt

Soda ash

Stirring implement

Water bottle, filled with water and sealed

1. Wash and prepare the T-shirt in the usual way (see page 23). Give it a good shake, lay it on a table and smooth out all the creases. Right in the bottom left hand corner, create a crease about 2/3 inch (1.5 cm) deep with the fabric. You must grab both the front and back layers. Lace the crease through the teeth of the fork. Holding it in an upright position, twist the fork in a clockwise direction. More folds will rise up, spiralling out from the fork. Smooth these folds with your free hand around the center twist, until you have a Chelsea bun-like shape.

2. When you get to the sleeves, do not panic, just keep going. Pretend the fabric is one continuous piece. Once the whole thing is a neat bundle, secure the folds in place with three elastic bands. The elastic bands should be evenly spaced. They should be tight enough to hold the folds securely in place, but not so tight that they cause the whole bundle to crinkle up.

3. Experiment with the empty bucket first; make sure the bundle fits when flat.

4. Boil the kettle and pour 2 quarts (2 L) water into the bucket. Stir in the dye, the salt and the soda ash and make sure all the lumps are dissolved. Follow the All-in method on page 25.

5. Place the bundle in the dye and jiggle the bucket gently back and forth for 5 mins. Place the filled water bottle on top of the fabric to weigh it down.

6. Leave it to stand overnight. Wash thoroughly until the water runs completely clear. Add fabric softener to the last rinse. Dry flat indoors.

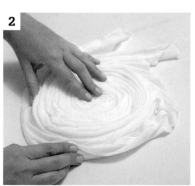

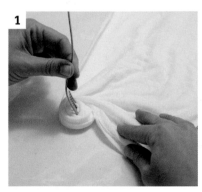

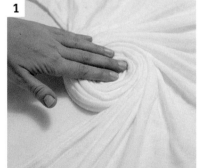

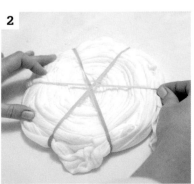

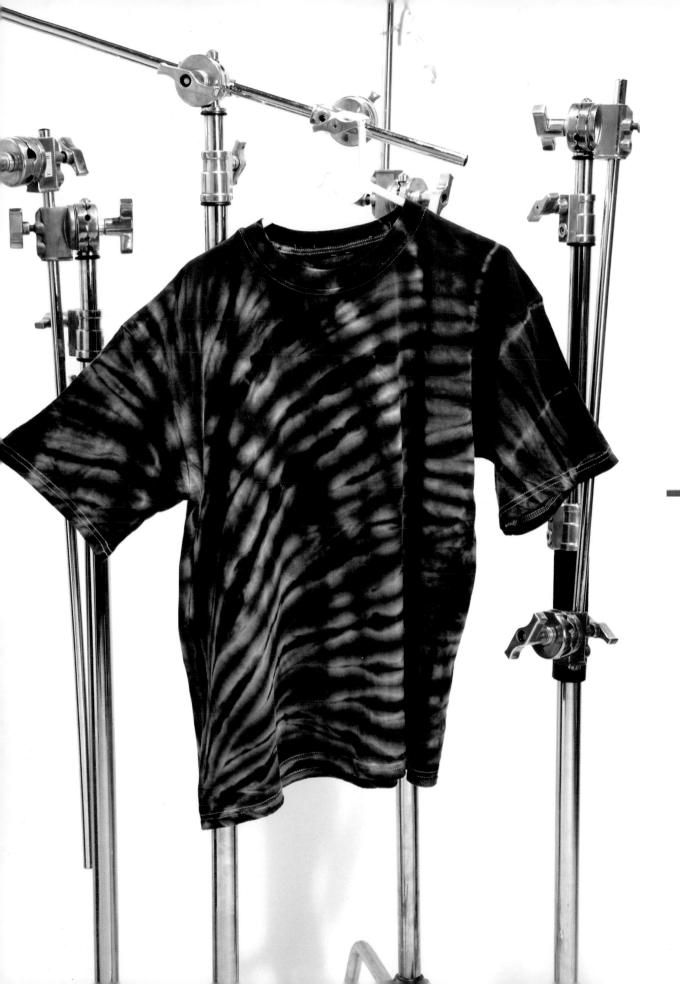

Two-color spiral T-shirt

You might want to try this two-color spiral first to build up confidence before you move on to the full-color version on the following pages (118–119).

1. Wash and prepare the T-shirt (see page 23). Give it a good shake, lay it on a table and smooth out all the creases. In the center of the chest, create a crease about 2/3 inch (1.5 cm) deep with the fabric. You must grab both the front and back layers. Lace the crease through the teeth of the fork. Holding it in an upright position, twist the fork in a clockwise direction. More folds will rise up, spiralling out from the fork. Smooth these folds with your free hand around the center twist, until you have a Chelsea bun sort of shape.

2. When you get to the sleeves, do not panic, just keep going. Pretend the fabric is one continuous piece. Once the whole thing is a neat bundle, secure the folds in place with three elastic bands. The elastic bands should be evenly spaced and must cross over the center of the twist that you created. They should be tight enough to hold the folds securely in place, but not so tight that they cause the whole bundle to crinkle up.

3. Experiment with your empty bucket first. Place the bundle in the bucket on its side and gauge how much liquid you will need to get the dye exactly up to the center line so that it runs across the center of the twist. Remember the fabric will displace the fluid a little. Make allowance for this.

4. Boil the kettle and pour 2 quarts (2 L) water into the bucket. Stir in the first color, the salt and the soda ash and make sure all the lumps are dissolved. Pour the required amount of dye into the bottom of the second bucket.

5. Place the bundle in the dye on its side with the fluid up to the center line and jiggle it gently back and forth for 5 mins. Use the crocodile clip to secure the bundle so that it does not fall over into the dye. Leave it to stand overnight.

6. Remove the bundle from the dye and leave it to drain.

7. Boil the kettle and pour 2 quarts (2 L) water into the bucket. Stir in the second color, the salt and the soda ash and make sure all the lumps are dissolved. Pour the required amount of dye into the bottom of the second bucket.

8. Place the bundle in the dye on its other side with the fluid up to the center line and jiggle it gently back and forth for 5 mins. Secure the bundle with a crocodile clip so that it does not fall over. Leave it to stand overnight.

9. Rinse in the usual way (see pages 25–27) and dry flat or on a hanger indoors.

intermediate

YOU WILL NEED

100% cotton white T-shirt

Strong elastic bands

Fork

Two 2-quart (2 L) buckets

Kettle

Blue and purple dye

Salt

Soda ash

Stirring implement

Crocodile clip

Tip: *Do not grind down on the teeth of the fork or you will make holes in the fabric. Simply use it as a handle to turn the shirt. Once you no longer need it, gently slip it from between the layers.*

spirals

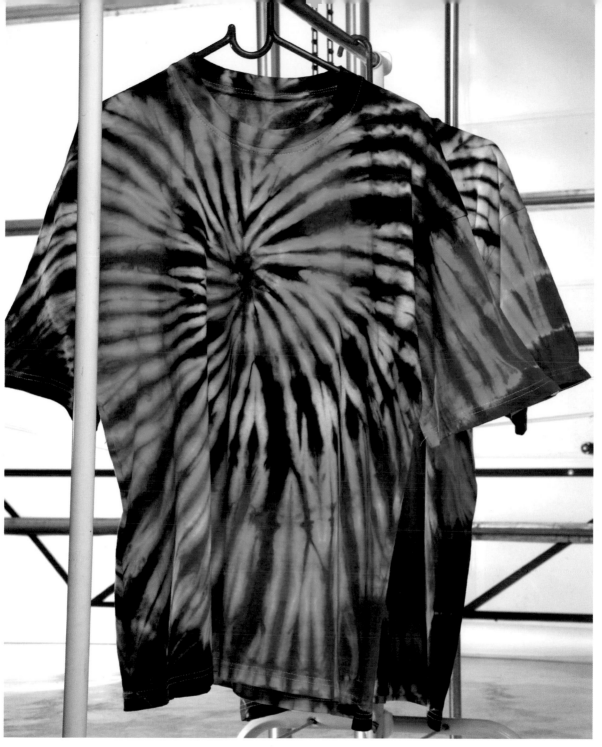

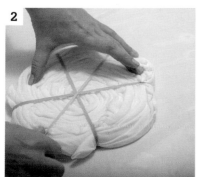

2

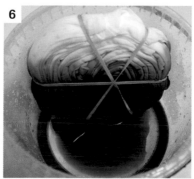

6

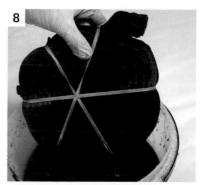

8

Rainbow spiral dress

Everybody loves a rainbow. Find out just how much when you wear this dress.

1. Wash and prepare the dress (see step 2, page 23). Give it a good shake, lay it on a table and smooth out all the creases. In the center of the chest, create a crease about 2/3 inch (1.5 cm) deep with the fabric. You must grab both the front and back layers. Grab the crease with a vice grip. Holding it in an upright position, twist the vice grip in a clockwise direction. More folds will rise up, spiralling out from the vice. Smooth these folds with your free hand around the center twist, until you have a Chelsea bun-like shape.

2. Once the whole thing is a neat bundle, secure the folds in place with three elastic bands. The elastic bands should be evenly spaced and must cross over the center of the twist that you created. They should be tight enough to hold the folds securely in place, but not so tight that they cause the whole bundle to crinkle up.

3. Place the dress on a wire grid. Boil the kettle and pour 2 quarts (2 L) water into the bucket. Stir in the gold dye, the salt and the soda ash and make sure all the lumps are dissolved.

4. Choose one half of the bundle and run the gold dye onto the fabric with the syringe. Do so until the color runs through the bottom of the bundle.

5. Boil the kettle and pour 2 quarts (2 L) water into the bucket. Stir in the pink dye, the salt and the soda ash and make sure all the lumps are dissolved.

6. Syringe the pink dye onto half the bundle, working on two clean sections and overlapping one of the gold ones. Run color on with the syringe until it runs right through the fabric from the top.

7. Boil the kettle and pour 2 quarts (2 L) water into the bucket. Stir in the turquoise dye, the salt and the soda ash and make sure all the lumps are dissolved.

8. Use the syringe to run dye onto half of the shape to cover the remaining white slice and overlapping one of each of the other colored slices. Make sure that the color runs right through the fabric from the top.

9. Wrap the bundle in three plastic bags, place the whole thing just like that in the bottom of a large bowl and heat up in the microwave (see page 25 for details on dying in the microwave). Leave it to stand overnight.

11. Rinse carefully (see pages 25–27) and dry flat or on a hanger indoors.

YOU WILL NEED

100% cotton white dress

3 strong elastic bands

Vice grip

Three 2-quart (2 L) buckets

Kettle

Gold, pink and turquoise dye

Salt

Soda ash

Stirring implement

Wire grid or drying rack

Syringe

Plastic bags

Microwave oven

Large bowl

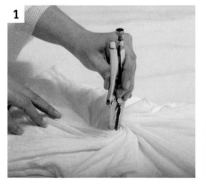

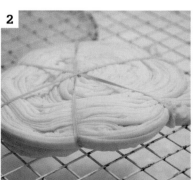

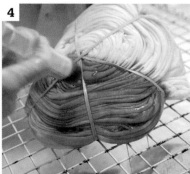

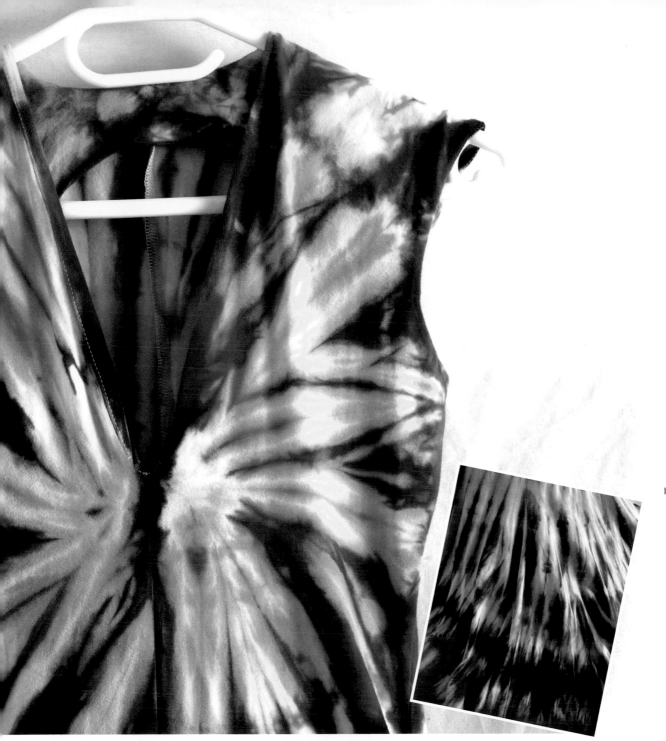

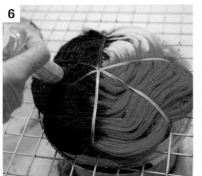

6

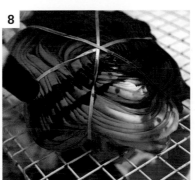

8

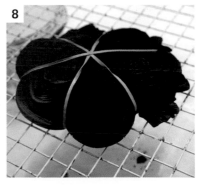

8

Double-spiral silk

Even spirals can be repeated by simply adding an extra fold.

1. Wash and prepare the fabric (see page 23). Give it a good shake, lay it on a table and smooth out all the creases. Fold the fabric in half. Choose where you would like the center of the shape to be. Create a crease about 2/3 inch (1.5 cm) deep with the fabric. You must grab both layers of fabric. Lace the crease through the teeth of the fork. Holding it in an upright position, twist the fork in a clockwise direction. More folds will rise up, spiralling out from the fork. Smooth these folds with your free hand around the center twist, until you have a Chelsea bun-like shape.

Tip: *Do not grind down on the teeth of the fork or you will make holes in the fabric, especially with silk! Simply use it as a handle to turn the fabric. Once you no longer need it, gently slip it from between the layers.*

2. Once the whole thing is a neat bundle, secure the folds in place with three elastic bands. The elastic bands should be evenly spaced and must cross over the center of the twist that you created. They should be tight enough to hold the folds securely in place, but not so tight that they cause the whole bundle to crinkle up.

3. Experiment with your empty bucket first. Place the bundle in the bucket on its side and gauge how much liquid you will need to get the dye exactly up to the center line so that it runs across the center of the twist. Remember the fabric will displace the fluid a little. Make allowance for this. If your bucket is too big, downsize to a yogurt container.

4. Boil the kettle and pour 2 quarts (2 L) water into the bucket. Stir in the gold dye, the salt and the soda ash and make sure all the lumps are dissolved. Pour the required amount of dye into the bottom of the second bucket.

5. Place the bundle in the dye on its side with the fluid up to the center line and jiggle it gently back and forth for 10 mins. Remove it from the dye and leave to drain.

6. Boil the kettle and pour 2 quarts (2 L) water into the bucket. Stir in the pink dye, the salt and the soda ash and make sure all the lumps are dissolved. Pour the required amount of dye into the bottom of the second bucket.

7. Turn the bundle and place it in the dye on its other side with the fluid up to the center line, overlapping one of the gold slices and jiggle it gently back and forth for 10 mins.

8. Boil the kettle and pour 2 quarts (2 L) water into the bucket. Stir in the turquoise dye, the salt and the soda ash and make sure all the lumps are dissolved. Pour the required amount of dye into the bottom of the second bucket.

9. Turn the bundle and place it in the dye on its other side with the fluid up to the center line, overlapping one of the yellow slices and one of the pink slices and jiggle it gently back and forth for 10 mins.

10. Rinse in the usual way (see pages 25–27). Dry flat or on a hanger indoors.

spirals

YOU WILL NEED

2 yards (2 m) white chiffon silk

3 strong elastic bands

Fork

Two 5-quart (5 L) buckets

Kettle

Gold, pink and turquoise dye

Salt

Soda ash

Stirring implement

Crocodile clip

Tip: *Silk should not be exposed to the dye for much more than an hour.*

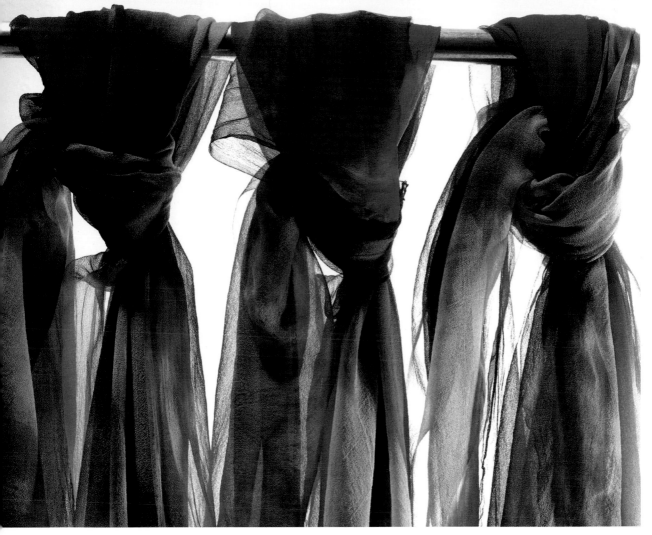

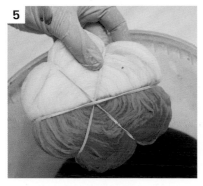

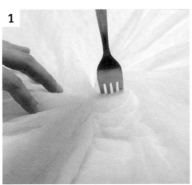

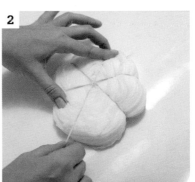

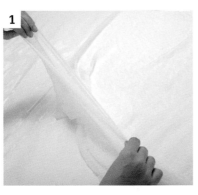

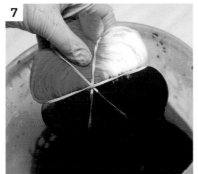

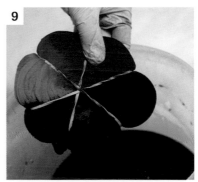

Zebra T-shirt

This technique in black on a white T-shirt always looks just like a zebra to me. Used on a dress, it is eye-catching and elegant.

1. Wash and prepare the T-shirt (see step 2 on page 23). Give it a good shake, lay it on a table and smooth out all the creases. Fold the T-shirt down the center and line up the hem and sleeves. In the corner where the sleeve meets the body, lace the fabric through the teeth of the fork. You must grab both layers, front and back. Hold it in an upright position and twist the fork in a clockwise direction. More folds will rise up, spiralling out from the fork. Smooth these with your free hand around the center twist, until you have a Chelsea bun-like shape.

2. Once the whole thing is a neat bundle, secure the folds in place with three elastic bands. The elastic bands should be evenly spaced. They should be tight enough to hold the folds securely in place, but not so tight that they cause the whole bundle to crinkle up.

3. Experiment with your empty bucket first. Place the bundle flat in the bottom of the bucket to make sure it fits.

4. Boil the kettle and pour 2 quarts (2 L) water into the bucket. Stir in the dye, the salt and the soda ash and make sure all the lumps are dissolved. Follow the All-in method on page 25. Place the bundle in the dye and jiggle the bucket gently back and forth for 10 mins. Place the filled water bottle on top of the fabric to sink it beneath the surface of the fluid.

5. Leave it to stand overnight. Wash thoroughly until the water runs completely clear. Add fabric softener to the last rinse. Dry flat indoors.

spirals

easy

YOU WILL NEED

100% cotton white T-shirt (or dress)

Strong elastic bands

Fork

Bucket

Kettle

Black dye

Salt

Soda ash

Stirring implement

Water bottle, filled with water and sealed

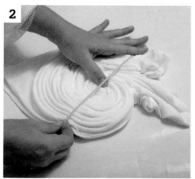

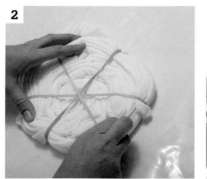

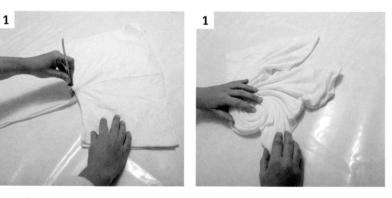

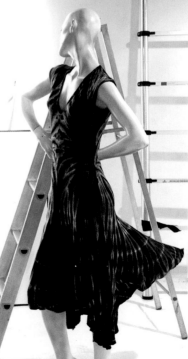

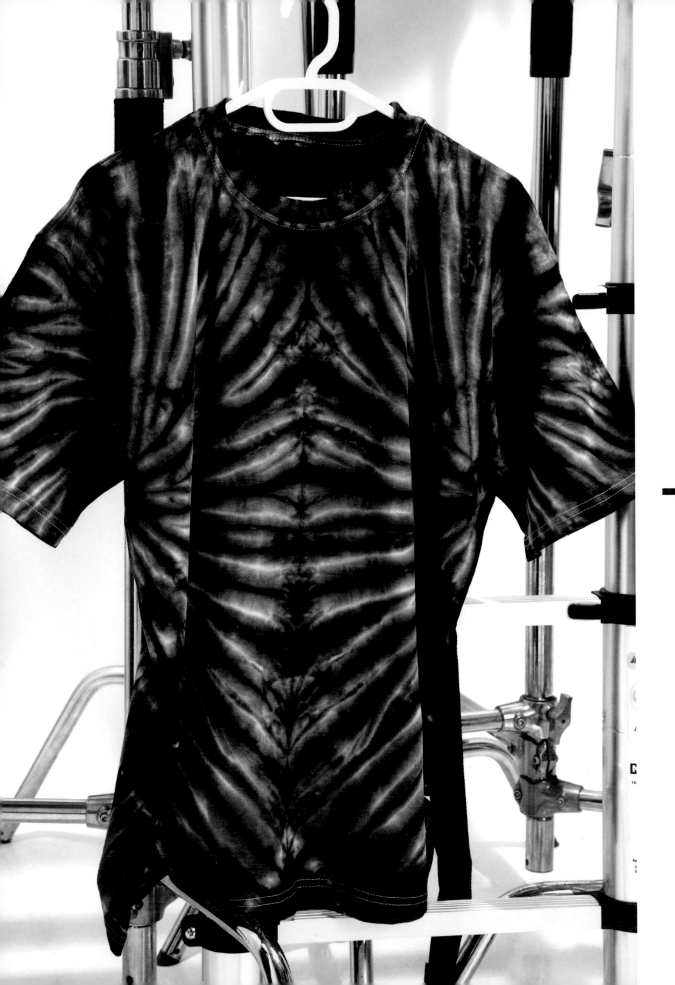

contemporary dyecraft

Tiger T-shirt

This striking pattern is very popular with boys and girls alike. The symmetrical balance of the design is pleasing to the eye.

1. Wash and prepare the T-shirt in the usual way (see step 2 on page 23). Give it a good shake, lay it on a table and smooth out all the creases. Fold the T-shirt down the center and line up hem and sleeves. In the corner where the sleeve meets the body, lace the fabric through the teeth of the fork. You must grab both the front and back layers. Hold it in an upright position and twist the fork in a clockwise direction. More folds will rise up, spiralling out from the fork. Smooth these folds with your free hand around the center twist, until you have a Chelsea bun-like shape.

2. Once the whole thing is a neat bundle, secure the folds in place with three elastic bands. The elastic bands should be evenly spaced. They should be tight enough to hold the folds securely in place, but not so tight that they cause the whole bundle to crinkle up.

3. Experiment with your empty bucket first. Place the bundle flat in the bottom of the container to make sure it fits.

4. Put on your protective gear. Pour 3/4 inch (2 cm) of bleach into the bottom of the bucket. Place the T-shirt in the bleach for 30 seconds and jiggle it around. Turn it over and do the same on the other side. Remove it from the bleach and watch the color change. When the color change is clearly visible, plunge the T-shirt into clean cold water and wash thoroughly.

Tip: *Wash until you are completely rid of the smell of the bleach. If you do not rinse the fabric properly, the bleach will eat away at the fibers and cause holes.*

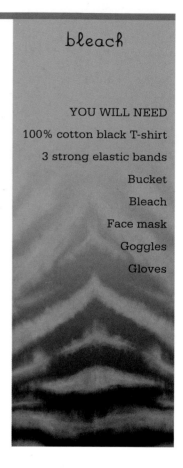

bleach

YOU WILL NEED

100% cotton black T-shirt

3 strong elastic bands

Bucket

Bleach

Face mask

Goggles

Gloves

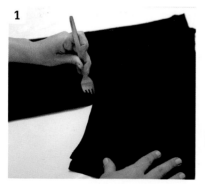

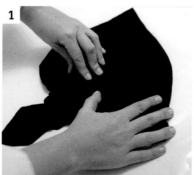

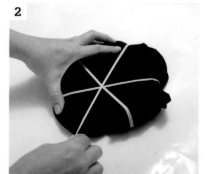

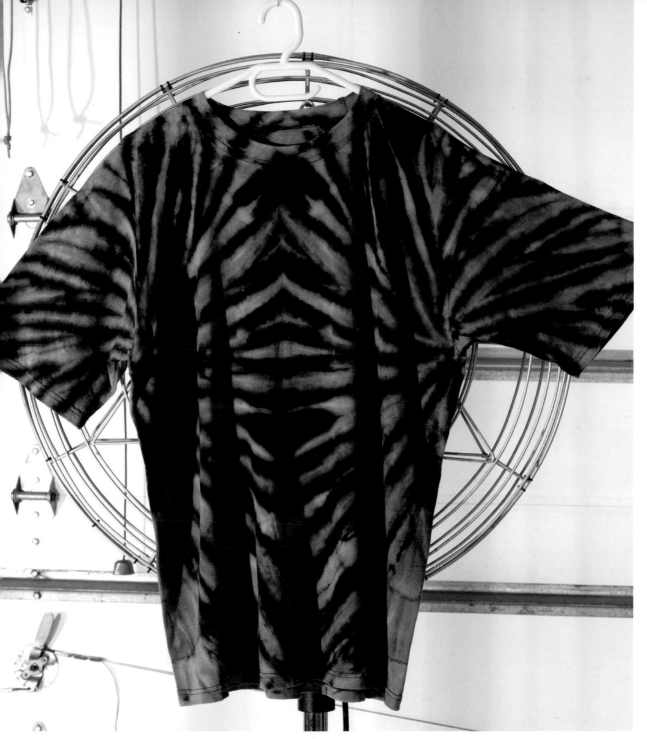

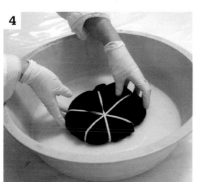

4

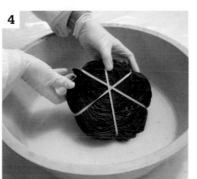

4

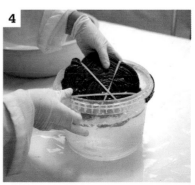

4

Feathers T-shirt

The result of this binding technique is equally striking in two colors.

1. Wash and prepare the T-shirt in the usual way (see step 2 on page 23). Give it a good shake, lay it on a table and smooth out all the creases. Fold the T-shirt down the center and line up the hem and sleeves. In the corner where the sleeve meets the body, lace the fabric through the teeth of the fork. You must grab both the front and back layers. Hold it in an upright position and twist the fork in a clockwise direction. More folds will rise up, spiralling out from the fork. Smooth these folds with your free hand around the center twist, until you have a Chelsea bun-like shape.

2. Once the whole thing is a neat bundle, secure the folds in place with three elastic bands. The elastic bands should be evenly spaced. They should be tight enough to hold the folds securely in place, but not so tight that they cause the whole bundle to crinkle up.

3. Experiment with your empty container first. Place the bundle flat in the bottom of the container to make sure it fits.

4. Boil the kettle and pour 2 quarts (2 L) water into the bucket. Stir in the first color, the salt and the soda ash and make sure all the lumps are dissolved. Pour 3/4 inch (2 cm) of dye into the bottom of the second bucket and place the bundle flat into it. Jiggle the bucket for at least 5 mins. Leave it to stand for at least an hour.

5. Remove it from the dye and leave one side to drain.

6. Boil the kettle and pour 2 quarts (2 L) water into the bucket. Stir in the second color, the salt and the soda ash and make sure all the lumps are dissolved. Pour 3/4 inch (2 cm) of dye into the bottom of the second bucket. Place the bundle in the bottom of the container with the other surface in the dye and jiggle it for 5 mins. Leave it to stand overnight.

7. Rinse thoroughly until the water runs completely clear. Add fabric softener to the last rinse. Dry flat indoors.

YOU WILL NEED

100% cotton white T-shirt

3 strong elastic bands

Fork

2 buckets

Kettle

Brown and black dye

Salt

Soda ash

Stirring implement

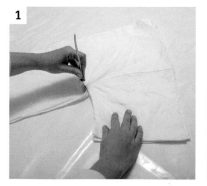

1

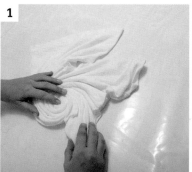

1

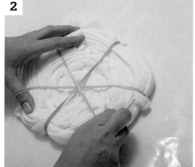

2

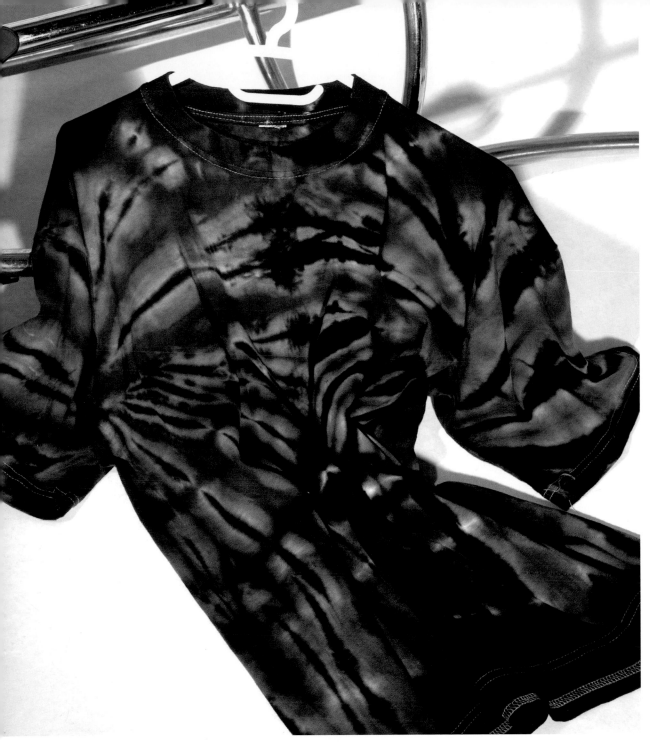

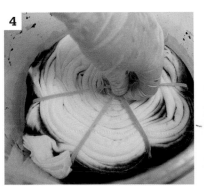

4

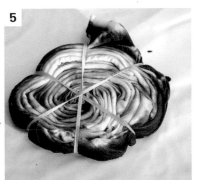

5

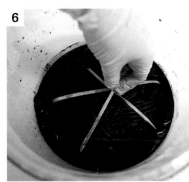

6

Rainbow feather dress

This dress uses a technique that's nearly identical to the method for Rainbow Spiral Dress (pages 118–119). It's a perfect example of how a minor change in how you fold the fabric can give a totally different result. This binding technique creates a design that is particularly flattering on the body.

1. Wash and prepare the dress (see page 23). Give it a good shake, lay it on a table and smooth out all the creases. Fold it down the center and line up the hem and arm holes. In the corner of the armpit, lace the fabric through the teeth of the fork. You must grab both layers, front and back. Hold it in an up-right position and twist the fork in a clockwise direction. More folds will rise up, spiralling out from the fork. Smooth these folds with your free hand around the center twist, until you have a Chelsea bun-like shape.

2. Once the whole thing is a neat bundle, secure the folds in place with three elastic bands. The elastic bands should be evenly spaced. They should be tight enough to hold the folds securely in place, but not so tight that they cause the whole bundle to crinkle up.

3. Place the dress on the wire grid. Boil the kettle and pour 2 quarts (2 L) water into the bucket. Stir in the gold dye, the salt and the soda ash and make sure all the lumps are dissolved.

4. Choose one half of the bundle and run the gold dye onto the fabric with the syringe until the color runs all the way through the bottom of the bundle.

5. Boil the kettle and pour 2 quarts (2 L) water into the bucket. Stir in the pink dye, the salt and the soda ash and make sure all the lumps are dissolved.

6. Syringe the pink dye onto half the bundle, working on two clean slices and overlapping one of the gold slices. Patiently run the colour on from the top until it penetrates all the layers on the way down.

7. Boil the kettle and pour 2 quarts (2 L) water into the bucket. Stir in the tur-quoise dye, the salt and the soda ash and make sure all the lumps are dissolved.

8. Use the syringe to run dye on to the remaining half of the shape to cover the white slice and overlap one of each of the other colors. Make sure that the bundle is completely saturated with color.

9. Wrap the bundle in three plastic bags, place the whole thing in a bowl and heat it in the microwave (see page 25 for details on dyeing in the microwave).

10. Leave it to stand overnight. Rinse it under a running tap to remove the worst of the excess before washing in the usual way (see pages 25–27).

advanced

YOU WILL NEED

100% cotton white dress

3 strong elastic bands

Fork

2 buckets

Kettle

Gold, pink and turquoise dye

Salt

Soda ash

Stirring implement

Wire grid or drying rack

Syringe

Plastic bags

Microwave oven

Large bowl

Tip: *Work fast. The quicker you get the fabric into the microwave once the dye is on, the more vibrant your colors will be.*

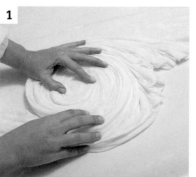

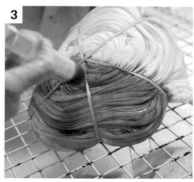

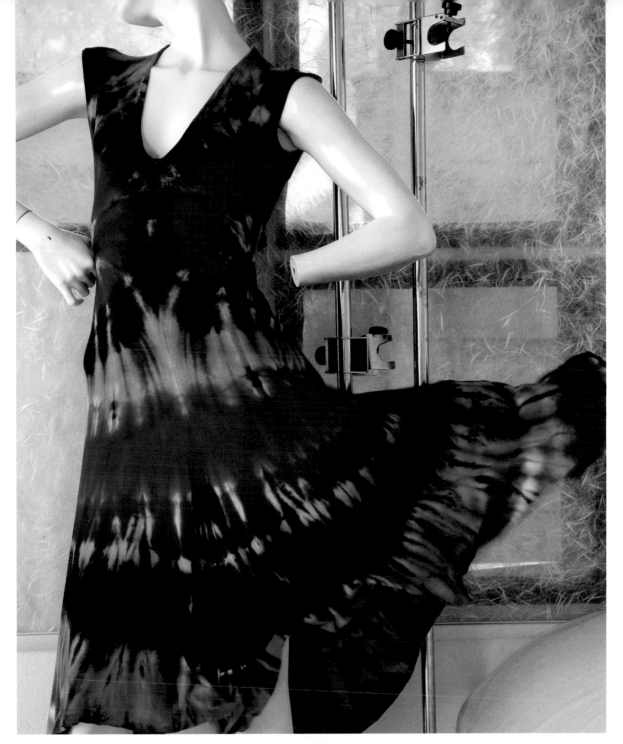

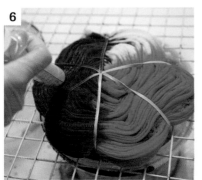

6

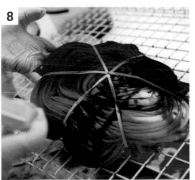

8

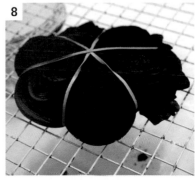

8

Multiple folds sheet

Create jungle themes on bedding with this variation of the spiral technique.

intermediate

YOU WILL NEED

100% cotton white bedding

Strong elastic bands

Cooking fork or vice grip

Large pot

Kettle

4 packets of black dye

Salt

Soda ash

Stirring implement

Water bottles, filled with water and sealed

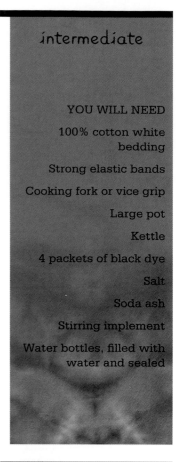

1. Wash and prepare the fabric (see page 23). Give it a good shake, lay it on a table and smooth out all the creases. Fold it down the center. Fold it in half again. In the middle of the fabric, create a crease about 3/4 inch (2 cm) deep and lace it through the teeth of the fork. Make sure you catch all the layers.

2. Hold it in an upright position and twist it in a clockwise direction. More folds will rise up, spiralling out from the center. Smooth these folds with your free hand around the center twist, until you have a Chelsea bun-like shape.

3. Once the whole thing is a neat bundle, secure the folds in place with three elastic bands. The elastic bands should be evenly spaced. They should be tight enough to hold the folds securely in place, but not so tight that they cause the whole bundle to crinkle up.

4. Experiment with your empty pot first. Place the bundle flat in the bottom of the pot to make sure it fits.

5. Boil the kettle and pour 8½ quarts (8 L) water into the pot. Stir in the dye, the salt and the soda ash and make sure all the lumps are dissolved. Place the bundle in the dye and stir the dye for 10 mins. Place filled water bottles on top of the fabric to sink it beneath the surface of the fluid.

6. Leave it to stand overnight. Wash thoroughly until the water runs completely clear. Add fabric softener to the last rinse. Dry flat indoors.

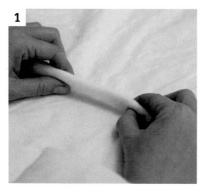

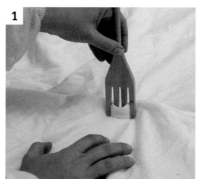

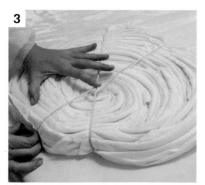

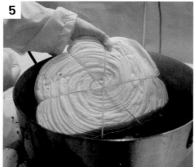

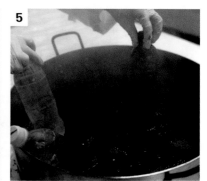

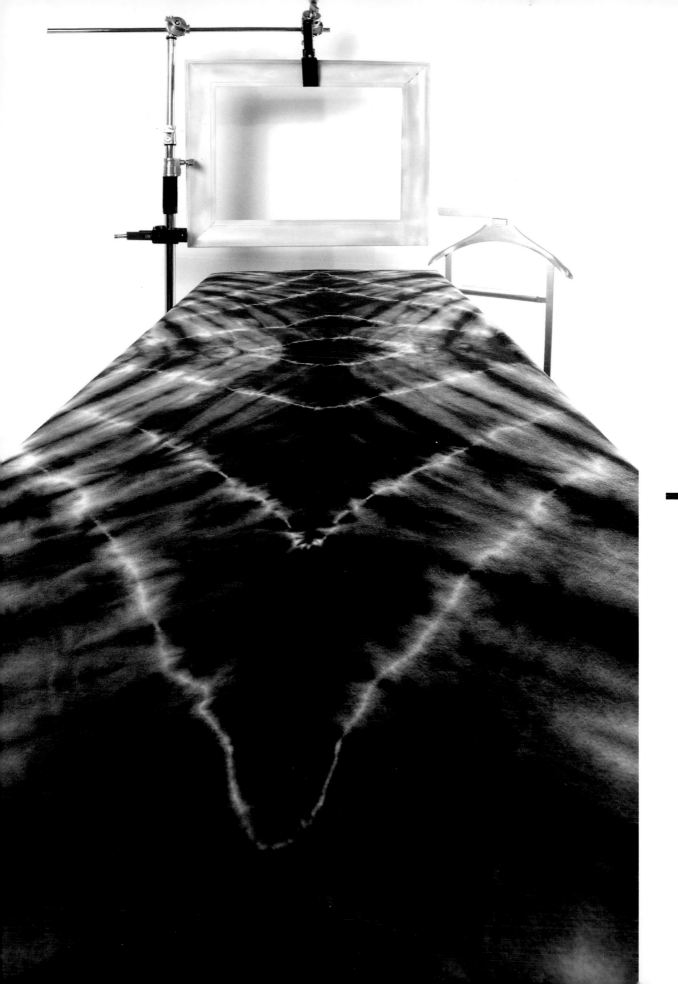

Rainbow bed throw

Rainbows create cheerful bedrooms for everybody!

1. Wash and prepare the fabric in the usual way (see step 2, page 23). Give it a good shake, lay it on a table and smooth out all the creases. Fold it down the center. Fold it in half again. In middle the of the fabric, create a crease about 3/4 inch (2 cm) deep and lace it through the teeth of the fork. You must make sure you catch all the layers.

2. Hold it in an upright position and twist it in a clockwise direction. More folds will rise up, spiralling out from the center. Smooth these folds with your free hand around the center twist, until you have a Chelsea bun-like shape.

3. Once the whole thing is a neat bundle, secure the folds in place with three elastic bands. The elastic bands should be evenly spaced. They should be tight enough to hold the folds securely in place, but not so tight that they cause the whole bundle to crinkle up.

4. Experiment with your empty pot first. Place the bundle in the pot on its side and gauge how much liquid you will need to get the dye exactly up to the center line so that it runs across the center of the twist. Remember the fabric will displace the fluid a little. Make allowance for this.

5. Add the appropriate amount of water to your pot and stir in the gold dye, the salt and the soda ash. Make sure all the lumps are dissolved.

6. Place the bundle in the dye on its side with the fluid up to the center line and jiggle it gently back and forth for 10 mins. Leave it to stand overnight.

YOU WILL NEED

100% cotton white bedding

Strong elastic bands

Cooking fork or vice grip

1 large pot

Kettle

Gold, pink and turquoise dye (3 packets each)

Salt

Soda ash

Stirring implement

Crocodile clips

Hose (for rinsing)

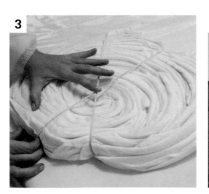

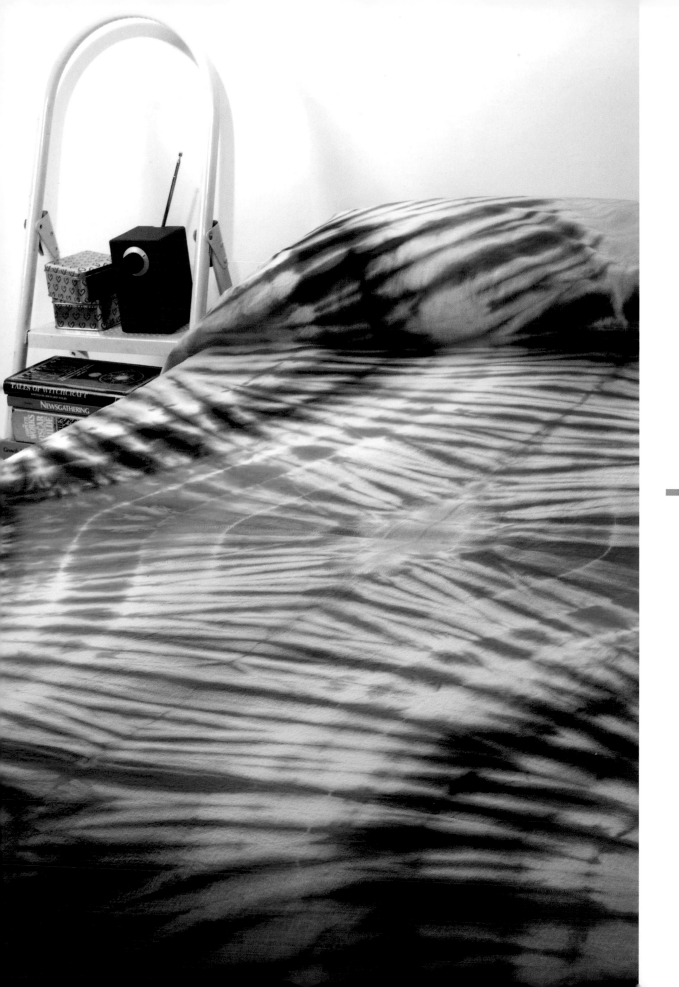

7. Remove it from the dye and leave it to drain.

8. Add the appropriate amount of water to your pot and stir in the pink dye, the salt and the soda ash. Make sure all the lumps are dissolved.

9. Turn the bundle and place it in the dye on its other side with the fluid up to the center line, overlapping one of the gold slices and jiggle it gently back and forth for 10 mins. Leave it to stand overnight.

10. Add the appropriate amount of water to your pot and stir in the turquoise dye, the salt and the soda ash. Make sure all the lumps are dissolved.

11. Turn the bundle and place it in the dye on its other side with the fluid up to the center line, overlapping one of the gold slices and one of the pink slices and jiggle it gently back and forth for 10 mins. Leave it to stand overnight.

12. Rinse away the worst of the excess dye with a hose before putting it in a bucket of soapy water. This will ensure that there is not too much waste dye in the water that could spoil your result. Rinse carefully and thoroughly (see pages 25–27) and dry flat indoors.

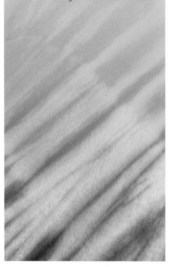

Tip: *Do not fold the wet fabric. Instead, dry it flat Even when you think you have washed the fabric very well, waste dye might still travel from a dark area onto a light area and spoil your pattern that you have worked so hard to achieve.*

The bigger the item you work with, the more care you should take.

spirals

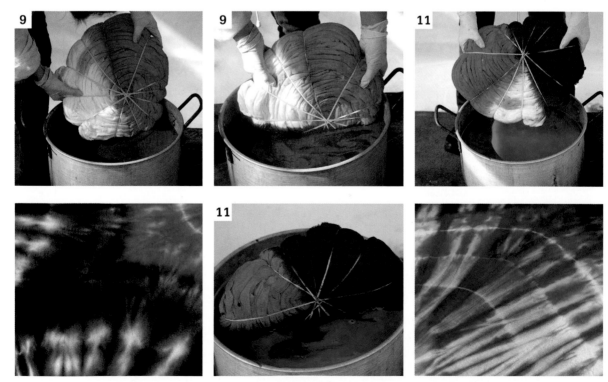

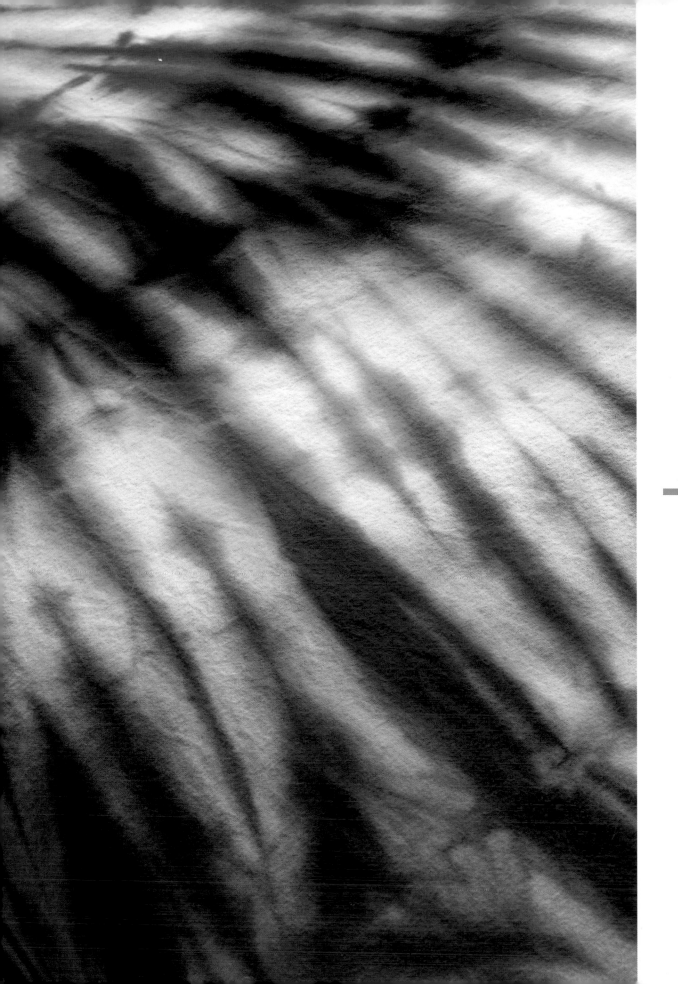

children's heart T-shirt

Everybody loves hearts, especially little girls. Stitch this pattern into a pink T-shirt to warm your daughter's heart.

1. Wash and prepare the fabric (see step 2, page 23). Give it a good shake, lay it on a table and smooth out all the creases. Fold it down the center and line up the hem and sleeves. Using the chalk, draw half of a heart along the center fold on the chest. Double up the thread to make it stronger and thread it through the needle. Stitch along the chalk line with even-running tacking stitches approximately 1/2 inch (1 cm) long. Start your first stitch and end your last stitch as close to the edge of the fabric as possible.

2. Draw the string in and gather the fabric tightly. Wrap the thread around the gather line and pull it as tight as possible without breaking the thread. Tie it off. Wrap a very tight elastic band in a closed position (looped to form a solid band) over that line.

3. Draw the folds of the fabric smoothly downward and add another elastic band approximately 1¾ inches (3 cm) from the first one in a closed position.

4. Boil the kettle and pour 2 quarts (2 L) water into the bucket. Stir in the red dye, the salt and the soda ash and make sure all the lumps are dissolved. Place the bundle in the dye and jiggle the bucket gently back and forth for 10 mins. Place the filled water bottle on top of the fabric to sink it beneath the surface of the fluid.

5. Leave it to stand overnight. Rinse thoroughly until the water runs completely clear (see pages 25–27). Add fabric softener to the last rinse. Dry flat indoors.

YOU WILL NEED

100% cotton pink T-shirt
Chalk
Needle
Strong thread
Scissors
2 strong elastic bands
Bucket
Kettle
Red dye
Salt
Soda ash
Stirring implement
Water bottle filled with water and sealed

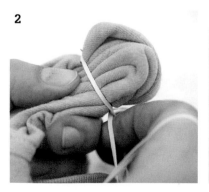

1

1

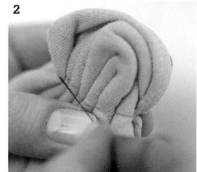

2

2

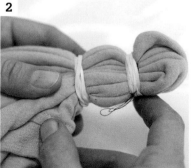

2

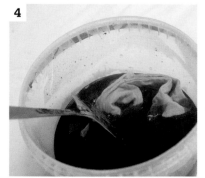

4

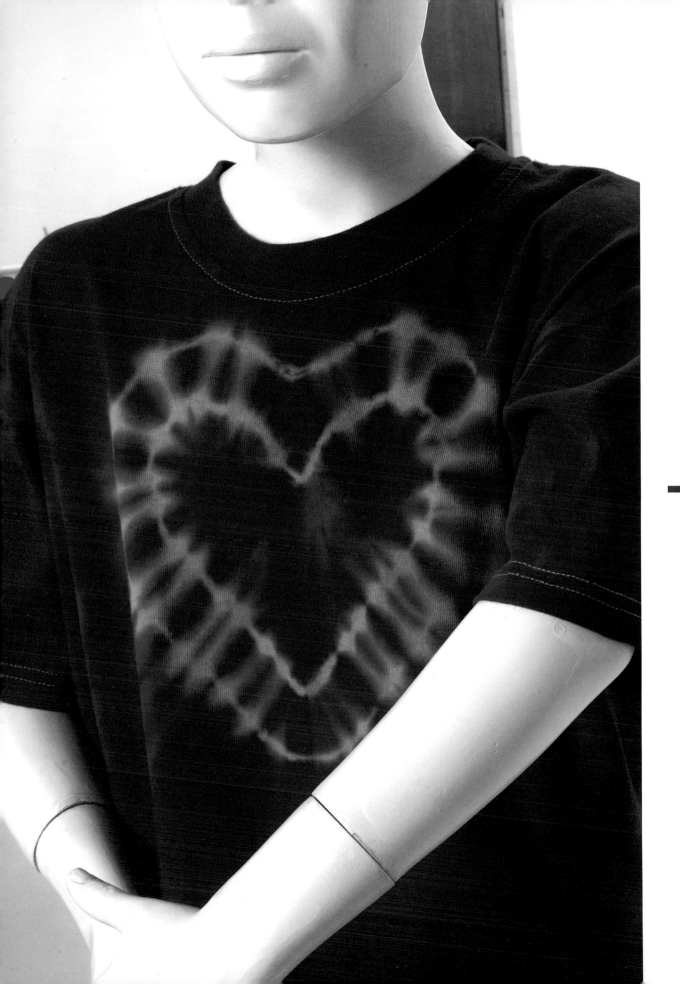

Floating heart towel

It is not necessary to dye an entire item. Add some fun to your bath towels with floating hearts.

1. Wash and prepare the fabric in the usual way (see step 2 on page 23). Give it a good shake, lay it on a table and smooth out all the creases. Fold it down the center and line up the hem and edges. Decide where you would like to place the heart and in which direction you should place it so that it is the right way up on the towel rail.

2. Draw half a heart along the center fold. Double up the thread to make it stronger and thread it through the needle. Stitch along the chalk line with even-running tacking stitches approximately 3/4 inch (2 cm) long. Start your first stitch and end your last stitch as close to the edge of the fabric as possible.

3. Draw the string in and gather the fabric tightly. Wrap the thread around the gather line and pull it as tight as possible without breaking the thread. Tie it off. Wrap a very tight elastic band in a closed position (looped to form a solid band) over that line.

4. Boil the kettle and pour 2 quarts (2 L) water into the bucket. Stir in the purple dye, the salt and the soda ash and make sure all the lumps are dissolved.

5. Wrap the part of the towel that will not be dyed in plastic to protect the fabric from unwanted splashes and spills.

6. Attach the towel to a pole or bucket using the crocodile clips so that the stitched tip hangs into the dye and the rest of the towel is suspended above.

Tip: *If you drape the towel over the edge of the bucket, gravity turns it into a straw that will suck the dye out of the bucket and onto the floor. Therefore the fabric must hang from above.*

7. Leave it to stand overnight. Rinse it the following day under a running tap to remove the excess. Keep the pink half of the towel at the top so it is not spoiled by the waste run-off.

8. Wash the towel in cold water with lots of soap until the water runs completely clear. Add fabric softener to the last rinse. Dry flat indoors.

advanced

YOU WILL NEED

100% cotton pink towel

Chalk

Needle

Strong thread

2 strong elastic bands

Bucket

Kettle

Purple dye

Salt

Soda ash

Stirring implement

Crocodile clips

Tip: *The challenge with this project is to keep the pink section pristine. Often you will stain the background if it lies wet in a ball or if your rinsing water gets too dirty. Minimize the risk of setting color into the pink section by washing in cold water. Hot water might activate waste dye.*

stitched patterns

3

6

6

Multicolored heart silk

Little girls go crazy for hearts. And big girls find this scarf simply irresistible, too!

advanced

1. Wash and prepare the fabric (see page 23). Give it a good shake, lay it on a table and smooth out all the creases. Fold it down the center, in line with the selvage. Fold it in half again. Using the chalk, draw half a heart along the center fold. Double up the thread to make it stronger and thread it through the needle. Stitch along the chalk line with even-running tacking stitches approximately 1/2 inch (1 cm) long. Start your first stitch and end your last stitch as close to the edge of the fabric as possible.

2. Draw the string in and gather the fabric tightly. Wrap the thread around the gather line, pull it as tight as possible without breaking the thread and tie it off. Wrap a very tight elastic band in a closed position (looped to form a solid band) over that line.

3. Draw the folds of the fabric smoothly downward and add another elastic band approximately 2 inches (5 cm) from the first one in a closed position. Add a third elastic band at a similar interval.

4. Place the fabric on a wire grid.

5. Mix the three colors using the All-in method (see page 25) in three separate buckets.

6. Use the syringe to run red dye onto the first two segments from the tip of the bundle.

7. Run turquoise dye onto the two middle segments with the syringe. As you overlap the one red segment you will see it turn purple as the colors mix.

8. Add the navy to the remaining white segment.

9. Spread a plastic bag out flat. Transfer the shape onto the plastic and roll it up, making sure that you isolate all sections in their own plastic. In this way the individual colors will be protected. Wrap this bundle in a second plastic bag, and then in a third. Twist the end shut and place it in a large bowl. See page 25 for details on microwave dyeing. Heat the bundle until it's hot all the way through.

11. Rinse away the worst of the excess dye with a hose before putting it in a bucket of soapy water. This will ensure that there is not too much waste dye in the water that could spoil your result. Rinse carefully and thoroughly (see pages 25–27). Dry flat or on a hanger indoors.

YOU WILL NEED

2 yards (2 m) chiffon silk

Chalk

Needle

Strong thread

Scissors

3 strong elastic bands

3 buckets

Kettle

Red, turquoise and navy blue dye

Salt

Soda ash

Stirring implement

Wire grid

Syringe

Plastic bags

Large bowl

Microwave

Hose (for rinsing)

stitched patterns

1

2

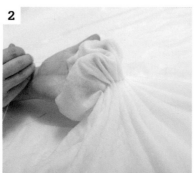

3

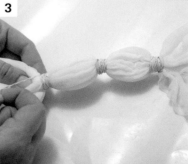

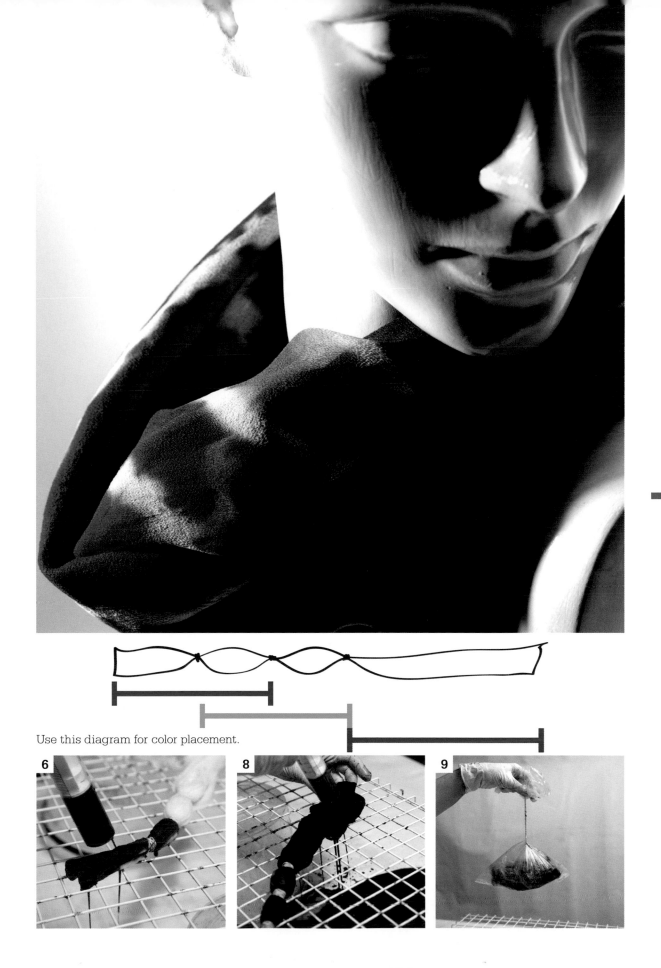

Use this diagram for color placement.

Five-color silk

Because it is so soft and pliant, chiffon silk lends itself perfectly to this complex stitched pattern. Try to keep the colors separate when applying the dye so that each one will be bold and vibrant.

1. Wash and prepare the fabric in the usual way (see page 23). Give it a good shake and lay it smoothly on a table. Draw the flag onto the fabric with chalk. Double up your thread so that it is stronger and thread it through the needle. Stitch along all the lines with 1/2 inch (1 cm) long even-tacking stitches. Gather the stitching tight and bind a very tight elastic over the thread in closed position (looped to form a solid band).

2. Place the fabric on the wire rack.

3. Mix each of the colors in a separate bucket using the All-in method outlined on page 25.

4. Use the diagram on the facing page for color placement. Draw up the colors in the syringe and run them onto the relevant areas. Go back and re-apply more dye, especially to the lighter segments. The darker colors tend to dominate.

5. Once all the color is on, wrap the fabric in lots of plastic. Make sure you isolate each color in its own plastic wrapping so that they do not run into each other if crushed. Wrap the bundle in more plastic and place it in your microwave in a large bowl for 2 mins on medium high (see page 25). Let it stand for an hour.

6. Rinse the fabric under a cold running tap to remove the excess. Wash thoroughly in warm soapy water until it runs clear. Add a little fabric softener to the last rinse.

advanced

YOU WILL NEED

2 yards (2 m) white chiffon silk

Needle

Strong thread

Five 2-quart (2 L) buckets

Kettle

Gold, red, royal blue, green and black dye

Salt

Soda ash

Stirring implement

Wire rack

Syringe

Plastic bags

Large bowl

Microwave

142

stitched patterns

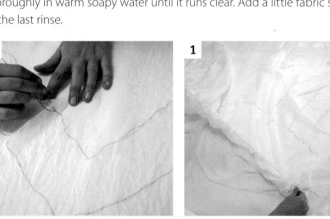

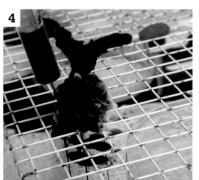

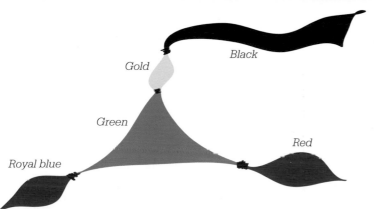

Black

Gold

Green

Red

Royal blue

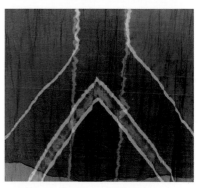

Acknowledgments

Special thanks must go to Ivan Naudé. His overall vision of what this book needed to be has helped me to craft a far finer product than I had ever dared hope when this journey began. He also made his studio and his fabulous gadgets and props available for the shoot.

For me the challenge was to make this book for everybody, so I bought many ready-made garments from stores in a mall. Most of the ladies garments were sourced this way.

- I wanted the dresses to be special so I had those made up by Wild Fig Clothing. Thank you Yoriko Alty for your quick turnaround and beautiful fabric.
- The T-shirts are from Vic Bay, suppliers of the SATees brand. They win the friendliest service award.
- The fabrics in the book come from Chamdor Faktry Sales in Northlands Deco Park. With such a wide selection, you can usually find what you need under one roof.
- Marilyn Burger supplied the impeccable quality chiffon silk that I used.
- Special thanks to Anna Castleman who does not like to make clothing, but who made me the Madiba shirts anyway. Thank you also for permission to use your Dreamcatcher Quilt in my book. You will always be my muse and greatest inspiration in color.
- Floyd's Barbershop in Fourways sponsored a mannequin for the shoot. Thank you to Robyne Buyers for setting it up. Preston van Wyk from X-Kulcha Clothing helped us with the rest. You guys are amazing.
- Thank you to Marianne Fassler for writing the foreword to this book, and for believing in me right from the start. You lead by example and I feel privileged to have had the opportunity to learn from your mentorship.
- This book is a finer product through my involvement with Raizcorp, my business incubator. To all my guides at school, you rock!
- Thank you to Anton Louw for the infrastructure and venue in which we created this book. Your support and patience while I tinkered on this project is very much appreciated.
- Finally I must thank Wilsia Metz, my publisher. This has been a truly amazing experience.

In life it is usually true that "the whole is greater than the sum of the parts." With such great "parts" to begin with, this book could only be a special thing.

I hope you enjoyed my book, and I look forward to seeing your tie-dyes all around me in the streets.